Praise for Phil Schoenberg's tour o

"How much do you really know about the city's ~~...~~ *ys, but in the cool of the evening, you can further* ~~...~~ *with Ghosts of New York Walking Tours.*

The weekly jaunts are filled with tales of skeletons in the Big Apple's closet…Channel the spirits of Edgar Allan Poe, Peter Stuyvesant and Harry Houdini…

Discover haunted locales, paranormal occurrences and unexplainable instances straight out of favorite ghost stories."

Adrianne Pasquarelli
"Things that Go Bump in the Street"

"If you're too scared to visit New York's most haunted spots solo, Phil Schoenberg, a history professor at Queens College, is the man for the job. His 'Ghosts of New York' tours offer three area- and ghost-specific tours of the city."

Gina Salamone
"New York City Is a Ghost Town"
Daily News
March 31, 2009

"I can't thank you enough for making the Ghost Tour possible for my daughter and our friends Saturday. Katya was lovely and a fount of information. It was a chilly day but we were all warmed by her enthusiasm and lively presentation. I will pass on the good word as often as I can."

Roma Torre
NY1 News Anchor

GHOSTS OF MANHATTAN

LEGENDARY SPIRITS AND NOTORIOUS HAUNTS

DR. PHILIP ERNEST SCHOENBERG

Onondaga Free Library

Haunted America

Published by Haunted America
A Division of The History Press
Charleston, SC 29403
www.historypress.net

Copyright © 2009 by Dr. Philip Schoenberg
All rights reserved

All photographs by Jeffrey Karg unless otherwise stated.

First published 2009

Manufactured in the United States

ISBN 978.1.59629.851.4

Library of Congress Cataloging-in-Publication Data

Schoenberg, Philip Ernest, 1948-
Ghosts of Manhattan : legendary spirits and notorious haunts / Philip Schoenberg.
p. cm.
Includes index.
ISBN 978-1-59629-851-4
1. Ghosts--New York (State)--New York. 2. Haunted places--New York (State)--New
York. 3. Tales--New York (State)--New York. I. Title.
BF1472.U6S337 2009
133.109747'1--dc22
2009036410

Firstly, I would like to dedicate this book in honor of my parents,
Nettie and Hyman Schoenberg.

Secondly, I would like to dedicate this work to my wonderful corps of tour guides
whom I have trained based on my research and who in turn enriched my study
of ghost lore: Matt Baker, Kathryn Carissimi, Annie Desmond, Jamie Owens,
Gordon Linzner, Katya Schapiro and my nephew Gabriel Schoenberg.

Thirdly, I would like to thank Caroline Ynez Jova, my NYU history intern
(2008–9), who was the first one to proofread the whole manuscript.

CONTENTS

Contents

FOREWORD

I have known Philip Ernest Schoenberg yclept (an archaic version of "also known as") "Dr. Phil" long before the "teleshrink" with the voice redolent of molasses and grits who burst on the scene via television talk shows co-opted the name.

Phil Schoenberg, licensed New York tour guide and walking tour entrepreneur, is a native of Queens County, New York, and has a doctorate in history. Other than accurately anticipating his clients' desires or creating a new product for them, he doesn't claim to offer psychotherapy.

Innovative as always, this Dr. Phil, truly an original, is developing a new tour niche—ghosts. This volume will be your appetizer prior to a feast of phantoms, spooks, wraiths and spirits of people and places in New York's glorious past.

—Lee Gelber

Lee Gelber is an urban historian/guide, dubbed "Dean of Guides" by the New York Times, *and is a member of the Guides Association of New York City. He includes architecture, Greenwich Village, Lower East Side, the Bronx and jazz tours among his specialties.*

INTRODUCTION

W hy are we fascinated by ghosts? Whether we are believers or skeptics, we are all fascinated by the unknown. When we die, is that it? Or do we get another opportunity in one way or another? Above all, if we cannot have life, we would like to be remembered in some way.

Why do we have ghosts? Usually, in most stories, the ghost has unfinished business of some kind and cannot let go. Often a traumatic incident such as a murder has occurred, or in very rare instances, a curse has been uttered. Thus, ghosts are usually unhappy; you do not frequently get a ghost that says, "Wish you were here."

The question is: are there really ghosts? Al Schroeder, a frequent letter writer to newspapers, comments that ghosts do not understand they are dead and are in a state of shock unable to understand what has happened to them. In an obituary on Hans Holzer, the noted ghost hunter, the *New York Times* quoted him: "After all, a ghost is only a fellow human being in trouble" who does not understand that he or she is no longer among the living because of sudden circumstances that transformed their fates. Likewise, in their *Village Voice* article "City of Ghosts," Tom Robbins and Jennifer Gonnerman noted that ghosts leave gaps of memory among their loved ones and friends.

On the negative side, the great British novelist Sir Walter Scott, in *Letters on Demonology and Witchcraft* (co-authored with J.G. Lockhart in 1836), was very careful in accepting the truth about ghost stories. Scott declared that it was one thing to enjoy ghost stories and another to determine if they really

occurred. He writes that an English judge stopped a witness from relating what the ghost of the murder victim had told him. The judge declared that repeating this evidence was hearsay. However, the judge noted, the ghost placed under oath would make an excellent witness and would provide the very best possible evidence and if the ghost could be placed under oath, he would be glad to have the ghost testify in court.

Did Edgar Allan Poe himself believe in ghosts? If you read carefully, children's author Daniel Cohen explains in his book *In Search of Ghosts* that Poe never wrote any real ghost stories, even though he is the father of the supernatural stories in America. He showed no interest in spiritualism, which became increasingly popular throughout the nineteenth century.

To further cloud the issue, we have fakes. Sir Arthur Conan Doyle believed in easily faked photographs of "faeries." Doyle had lost a son in World War I and turned to spiritualism as a comfort. This tendency often comes through in his plots and characters. His greatest Sherlock Holmes story, *The Hound of the Baskervilles*, revealed a faking of the supernatural to commit a series of murders. Doyle, modeling himself after the real doctor after whom he patterned Holmes, was an amateur detective and helped right several cases of injustice. His other well-known character, Professor Challenger, the discoverer of the Lost World, has a proclivity in believing in the supernatural. Doyle even wrote a book trying to prove that his friend Harry Houdini had supernatural powers, which the magician denied. As a result, their friendship came to end.

Mediums claim that they have a special spirit that communicates through them. Harry Houdini made a specialty of exposing these charlatans, and many have followed in his footsteps. For example, Uri Geller, an Israeli psychic, suffered psychic failure on Johnny Carson's show. Carson, a former professional magician, had his staff carefully watch Uri Geller so that he had no opportunity to monkey around with the props. The Great Randi through the James Randi Educational Foundation also continues Harry Houdini's crusade by offering $1 million to any psychic, professional or amateur who can professionally survive being unmasked. So far he has not had to pay out the money to mystical homeopathy buff Jacques Benveniste or *Crossing Over* host John Edward, who claims that he hears from the dead (or to University of Arizona scientist Gary Schwartz, who claims to have validated John Edwards). Johnny Carson once joked that he was waiting for the following newspaper headline: "Psychic wins the lottery."

PART I

GUIDE TO KNOWING YOUR GHOSTS

Types of Ghostly Encounters

Ghostly encounters can take the form of sound, sight, smell, touch, feeling, temperature and/or movement:

1. Visual or sight: a view of an entire being in real time or an orb, an unexplained source of light, which appears in a photograph. We now have YouTube to highlight the more dramatic encounters, while "orbs" are often spotted on photographs. Poltergeist activity such as the movement of an object without any visible force can be documented.

2. Auditory or sound: people hear a noise of some kind. Sometimes, this can be caught as an electronic voice phenomenon (EVP) on a sound recording device. At the same time, these sounds can be manufactured to fake the presence of ghosts. Some people have heard whistles.

3. Olfactory or smell: one can smell perfume, cologne, tobacco or burnt hair or flesh.

4. Tactile or touch: people can touch something.

5. Kinesthetic: One carries out a physical activity. For example, a person is possessed by the spirit or engage in automatic handwriting of some kind.

6. Feeling: people feel uneasy around places such as the scene of an accident, a fire or fatality. Oftentimes, pets (especially cats and dogs) seem to be sensitive to the presence of spirits.

7. Temperature: sudden decrease or increase of temperature or the feeling of a cold or warm spot.

WHERE YOU ARE LIKELY TO FIND GHOSTS

1. Where bodies have physically been buried: graveyards and churchyards. Religions have different conceptions of what happens to the deceased. Those of the Jewish faith believe that the body together with the soul will be physically resurrected. Christians and Muslims believe that the soul will be resurrected. Buddhists, Hindus and Sikhs believe in reincarnation. Peter Stuyvesant does his haunting around the family mausoleum at St. Mark's Church in the Bowery (after his mansion burned down).

2. Modern parks: many former burial spaces have been turned into green spaces with the deceased left in place. Washington Square Park, a former burial place for the poor, is ghost central in New York City. Greenwood Cemetery was designed to serve as a park for the living.

3. Where natural or unnatural deaths occurred but people are not buried. Sometimes disturbing the scene will stop ghostly phenomena or solving the crime will give the ghost rest. Once McGurk's Suicide Hall at 295 Bowery was torn down, the ghosts stopped haunting there.

4. Where people lived or worked: Edgar Allan Poe is reported at many locations at the same time: Baltimore, Richmond, Philadelphia, Boston and New York (Manhattan and the Bronx). Occasionally pets seem to be sensitive to ghostly visitors. People who have lived inside the apartments of St. Mark's Church in the Bowery have reported that their pet cats or dogs refuse to enter certain areas unless they are there.

5. Where people played: abandoned sports facilities, amusement parks and other places where people went to enjoy themselves. The New York Giants have failed to win the World Series since they moved to California to become the San Francisco Giants in 1957. Also, the memorial plaque of Edward L. Grant, the first baseball major leaguer to die in World War I, has disappeared from the Polo Grounds.

6. Where people drink alcohol: bars, inns and drinking establishments are most popular. McSorley's Old Ale House is where a variety of ghosts can be found.

7. Where people go for entertainment: theatres are popular places for ghosts to haunt or entertain. Judy Garland was channeled by psychic Elizabeth Barton at the Palace Theatre. Barton claimed that the theatre had more than one hundred ghosts reporting for guest haunts.

8. Where people travel: subway and railroad stations. Grand Central has its share of ghosts. Locomotion appears to attract some ghosts. In more recent times, people have reported giving rides to passengers who have

disappeared or when they go back to check the drop off point, they discover they once were at the location but are long dead. Staircases and elevators also appear to attract ghosts.

How Is the Value of a House Affected by the Presence of a Haunting?

We simply have no hard statistics. Some people welcome the presence of a ghost as a conversation piece, a way to make friends or to scare off burglars and other intruders. Others see ghosts as pests that disturb them, their friends and the surrounding neighborhood. Depending on the individual state law, you may or may not have an obligation to say whether or not there is a ghost. In the case of the mansion at 19 Gramercy Park South, its value has gone up the more haunted it has become. Over the years, the house has proved to be a successful real estate investment. Benjamin Sonnenberg paid $89,000 in 1945. Richard Tyler and his wife Lisa Trafficante paid $9,500,00 in 1995 and sold it for $19,000,000 in 2000.

The Ten Most Popular Ghosts of New York City

In terms of the frequency of reports over a period of time, there are many popular ghosts in New York City.

1. Most appearances by a single ghost: Edgar Allan Poe has been reported in several New York locations and several other cities at the same time. He has been reported as a ghost in Baltimore, Boston, Philadelphia and Richmond.
2. Most reported family of ghosts: the five Tredwell sisters sadly all haunt separately at the Merchant House.
3. Peter Stuyvesant is the oldest ghost in the city, with the most reports over a period of time.
4. David Belasco haunts several locations inside the Belasco Theatre, named after him.
5. Olive Thomas is a well-known spectral presence in the New Amsterdam Theatre.
6. Samuel Clemens appears as a specter at 14 West Tenth Street.
7. People report being spooked by Mrs. Eliza Jumel at the Morris Jumel Mansion.

8. Aaron Burr has been spotted at Battery Park and elsewhere in Manhattan.
9. Burr's daughter Theodosia has been reported up to ghostly mischief at One if by Land, Two if by Sea Restaurant at 17 Barrow Street in the West Village.
10. Washington Irving has been reported at his home in Upstate New York as well as a few locations in Manhattan such as the Colonnade.

HOW TO GET RID OF GHOSTS

1. Physical destruction of the site, although this does not always work. When Stuyvesant's mansion burned down in 1744, he moved his haunting to the Stuyvesant family mausoleum. Edgar Allan Poe no longer haunts at 85 West Third Street once NYU destroyed his original home.
2. Destruction or removal of the physical remains of the body. Once A.T. Stewart's body was moved from a secret hiding place near St. Mark's Church in the Bowery to the Episcopal cathedral in Garden City, he stopped haunting.
3. A séance is an encounter or meeting at which a spiritualist or a medium attempts to communicate with the spirits of the dead. The word "séance" comes from the French word for "seat," "session" or "sitting" and from the Old French word *seoir*, "to sit." Hans Holzer, through a medium, would chat with the spirit, find out what the problem was and try to solve it. If Holzer was successful, the supernatural activities would come to an end since the spirit was at rest. Such psychoanalysis might take several séances.
4. Exorcism (from the Latin word *exorcismus*, from the Greek word *exorkizein*, to abjure) is the practice of evicting demons or other spiritual entities from a person or place that they are believed to have possessed. An exorcist is the person called upon to perform this ceremony through prayer, ritual, formula or through some other means such as an angel or an amulet. Dr. Joseph Green Cogswell performed a secular exorcism at the Astor Library after he encountered Austin Sands.
5. Solving the problem that causes the ghost to haunt.
6. Simply informing the ghost that he or she is deceased! Sometimes, they don't know they are dead.
7. Suggesting to the ghost a better place to haunt.
8. Simply asking the ghost to leave or stop haunting.

9. Perhaps welcome the ghost as a friend.
10. Move away from the haunted location. When the *New York Times* moved uptown in 1904, the newspaper left its resident ghost behind.

DOCUMENTATION

When it comes to ghosts, we have to rely on various sources, from hearsay and legend to eyewitness testimony and photographs. There are people who hide in the shadows as "anonymous," and others like George Templeton Strong (noted diarist, lawyer and former mayor of New York), who relates a few ghost tales in his diary entries. Some are firsthand accounts based on an immediate experience, while others are warmed-over legends repeated without any effort at accuracy whatsoever. Some accounts are immediately broadcast through newspaper interviews, while others have to be ferreted out from obscure entries in diaries long after their authors have turned into dust.

Some places have the number of ghosts there hyped up or claim a link to a deceased writer without any basis in fact. Newspapers in the nineteenth century loved to report on the presence of ghosts. For example, many articles and guides repeat the claim that the "most haunted" house in the city is the townhouse at 14 West Tenth Street. They claim Samuel Clemens among its twenty-two ghostly denizens, but only a spectral appearance of Samuel Clemens has really been documented.

There is a plaque at 120 East Seventeenth Street and 49 Irving Place that claims that Irving lived there. Irving did visit a nephew there but never stayed overnight or did any writing there.

Someone claimed to be living at a building containing the former stables of Governor George Clinton in the West 40s. When I tried to find an exact address, I discovered that the governor died ten years earlier than the time during which his presence was claimed. He died in Washington, D.C., and was reinterred in his hometown of Kingston, New York. The informant claimed that a ghost unrelated to the governor was doing the haunting. I will discuss this further as "Old Moor" at 420 West Forty-sixth Street.

My purpose in retelling these stories is to present the best-documented cases in the most entertaining fashion possible. Washington Irving declared: "The tongue is the only tool that gets sharper with use." The book is organized by neighborhood and ghosts in alphabetical order for your convenience. Be forewarned, a ghost may be haunting in more than one neighborhood.

GHOSTLY NEIGHBORHOODS
AND THEIR INHABITANTS

New York Harbor

Ellis Island Pirate Ghosts

Ellis Island in the eighteenth century had the nickname of "Gibbet Island" because of all the pirates who swung there courtesy of the British, intent on stamping out piracy. Oyster clammers reported running into the ghosts. Pirates who escaped this fate would steer clear of the island in fear their former buddies would grab them and help them into the next world because misery loves company.

Henry Hudson, the Original "Flying Dutchman"

New York State traditionally has been torn in rivalry between "upstate" and "downstate." Henry Hudson is both a downstate and an upstate ghost. Henry Hudson, an English explorer working for the Dutch West India Company, was the first European to discover Manhattan Island and the Hudson River in 1609. His discovery of beavers and other fur-bearing animals caused the Dutch to come back to trade with the Indians and settle down to farm the land.

Every twenty years since 1609, Henry Hudson and his crew return to bowl ninepins with the gnomes of the Catskills Mountains. The crash of the

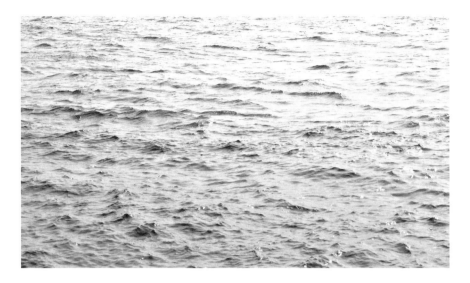

During stormy weather, Captain Henry Hudson may appear on his ship, the *Half Moon*, riding out a storm in New York Harbor because he is the original Flying Dutchman doomed to meander the seven seas.

pins is heard in the form of thunder. Sometimes this thunder is so loud it can be heard all the way down the Hudson River Valley in New York City. Washington Irving relates how Rip van Winkle encountered Henry Hudson and his crew in a game of ninepins in the story of the same name.

Henry Hudson became the original "Flying Dutchman." He was such a poor master of human relations that every one of his crews in his four voyages mutinied against him. In the last voyage, his crew set him adrift amid the ice floes of Hudson Bay, where he perished. None of the mutineers was punished for their evil deed. Ever since then, Hudson has been condemned to voyage around the world in search of justice. When severe weather occurs, mariners spot him being blown about by the storm. He has been spotted in or near New York Harbor on more than one occasion.

Captain William Kidd Protects His Treasure

Rumors, legends, myths and tales swept both sides of the Atlantic Ocean that Captain Kidd buried a fabulous horde of treasure before facing trial. Such treasure as Kidd did have—twenty four chests full of it—was all brought ashore on Gardiner's Island, off eastern Long Island, carefully inventoried

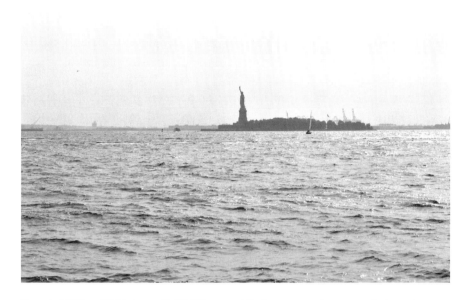

Captain William Kidd also trolls Wall Street to blind con men who try to sell shares in treasure-hunting expeditions to find his gold in vain. Today people come to view the Statue of Liberty instead of searching for Captain Kidd's treasure.

and, with the permission of John Gardiner, feudal lord of the island, buried in a swamp there. Gardiner's itemized receipt to Kidd, dated July 17, 1699, listed precisely 1,371.625 ounces (85.73 pounds) of gold, silver and precious stones that was reclaimed by the Massachusetts colonial government.

In 1825, two U.S. Army soldiers, Sergeant Gibbs and Private Woods, thought life had dealt them a winning hand. They were assigned to Fort Wood on Bedloe's Island (later renamed Liberty Island in honor of the Statue of Liberty). They spent their spare time at night hunting for buried treasure. When they opened a heavy metal box, Captain Kidd's spirit emerged. They fainted. When they regained consciousness, all they had was an empty box.

FINANCIAL DISTRICT

Adam Allyn, Washington Irving's First Ghost

Washington Irving, who grew up in the neighborhood, may have heard Allyn's giggles—from the grave. When he was six years old, his nanny

introduced him to George Washington. The great man gave the young child his blessing. Toward the end of his life, Irving completed one of his greatest works, a biography of the man whom he was named for: *George Washington* (1855–59).

The inscription on Adam Allyn's tombstone at Trinity Churchyard at 74 Trinity Place reads: "Sacred to the memory of Adam Allyn, Comedian. Who departed this life February 16, 1768. This Stone, was erected by the American Company as a testimony of their unfeigned regard. He possessed many good qualities. But as he was a man he had his frailties coarseness to man's nature." Over two hundred years after his death, Allyn must still be succeeding as a comedian because the sound of a high-pitched cackle can be heard from time to time—perhaps he has to supply his own laugh tracks to his jokes.

Matthew Brady, Still Photographing Away

Matthew Brady was a whiz with a camera. At a time when you had to stand still for a minute, he had a gift of making people come alive instead of looking as if they were dead. Ask Abraham Lincoln, who declared that the photograph he took in New York along with the speech he gave at Cooper Union in 1860 helped him become president of the United States. His studios at 55 Broadway in New York and Washington, D.C., were popular places for people to visit and where he took his photographs of the great people of the day. Brady made it his life's mission to document the bloody Civil War. His haunting began when the actual sign, which stood for another century promoting his studio, was finally taken down. Apparently, he still makes it his phantom mission to photograph, except he uses an e-camera now.

Aaron Burr on the Eternal Watch for His Daughter

Aaron Burr was quite a character. Unlike the other Founding Fathers, he was not a prolific writer and preferred to remain silent rather than to defend himself. He was a man of such contradictions that even his enemies could say kind things about him. George Washington and Thomas Jefferson blocked his career without any explanation. John Adams was one of his defenders. Perhaps it is all due to the fact that he was the father of modern political

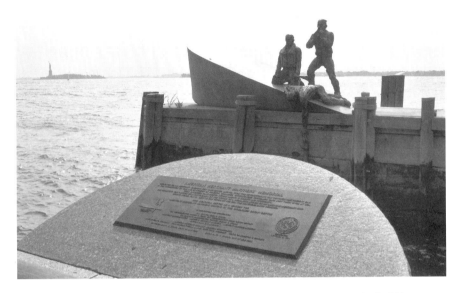

Forlorn Aaron Burr is forever doomed to be at Battery Park to await the arrival of his daughter Theodosia. Sometimes Aaron Burr joins the American Merchant Marine Memorial in Battery Park as he keeps watch for his daughter. Liberty Island is in the background.

campaigning. Unlike others, who encouraged the office to seek the man, Burr openly declared that man should seek the office. As late as the Civil War, politicians such as Abraham Lincoln cultivated the fiction that political office sought them.

Burr was an ardent feminist. He hung a portrait of Mary Shelley (née Mary Wollstonecraft Godwin) in his home. He gave his daughter every possible advantage in education that a son would have received. He was devoted to his first wife, who died in giving birth to his daughter, Theodosia. When she perished off the coast of the Carolinas, his personal papers that might have thrown a better light on his personal character were also lost.

In 1808, Thomas Jefferson had his former vice-president charged with treason. The presiding judge, John Marshall, strictly interpreted the U.S. Constitution in his charge to the jury. Marshall said that the U.S. Constitution demanded two witnesses to treason and that witnesses had to be supplied. Charles Wilkinson, head of the U.S. Army, a spy in the Spanish service, provided evidence that Burr had engaged in treason. However, he was laughed out of court when it turned out that the document, a copy of the supposed original, had been entirely written by him. Burr as vice president

had earlier presided over the impeachment trial of Samuel Chase in the U.S. Senate. His diligence and fairness as the presiding judicial authority helped the associate justice escape impeachment. As a result, Jefferson was unable to politically remove justices from the Supreme Court and elsewhere to have the judiciary rule in his favor. Marshall remembered what Burr had done and returned the favor.

Aaron Burr and his daughter Theodosia make an interesting pair of ghosts. On December 31, 1812, the beautiful and vivacious Theodosia Burr, wife of wealthy governor Joseph Alston of South Carolina, left her husband's plantation. She sailed north on the *Patriot* to visit her beloved father in New York City. In January 1813, British ships intercepted the vessel off Cape Hatteras of North Carolina. Though the two countries were at war, the ship was permitted to continue its voyage. The *Patriot* was never seen again. That very night, a storm swept North Carolina and swamped the boat. All the bodies except that of Theodosia washed ashore. Now and then reports emerge that a ghostly Aaron Burr still awaits his daughter at Battery Park.

Another version of the story has Theodosia taken aboard a pirate ship and forced to walk the plank. According to this account, Theodosia's ghost eventually arrived at her father's residence, at 3 Wall Street, where she and her dad remain in spooky tandem.

Still another version has her as an amnesiac who lived in a North Carolina town. She had treasure that had somehow survived the sinking, her portrait, which years later brought a fabulous sum at auction when its true worth was recognized after her death.

Robert Fulton, Still Inventing

Robert Fulton was an engineering genius who received financial backing and technological assistance from Robert R. Livingston, the American minister to France. It also helped that Fulton married Livingston's niece. In 1800, he designed a submarine for Napoleon Bonaparte. He also experimented with steam-driven boats on the Seine River before successfully launching the *North Wind*, or the *Clermont*, on the Hudson. When the War of 1812 commenced, Fulton designed the world's first steam-powered warship from funds raised by popular subscription.

With such a record of accomplishment, no wonder he became a ghost upon his death—he had so much unfinished business.

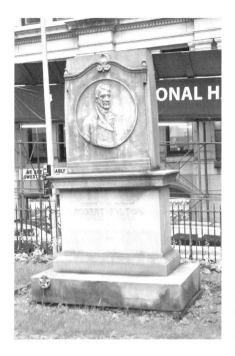

Robert Fulton, submarine, steamboat and steam warship inventor, is an ever-energetic ghost in search of new endeavors since he died so young. This is his grave at Trinity Church.

Fulton may be seen wandering and holding a model of his steamboat, the *Clermont*, in Trinity Churchyard at 74 Trinity Place. He started making his appearance when ferry boats stopped running after World War II, except for the Staten Island Ferry. His haunting has declined in the last few years as ferry service has returned to New York Harbor.

Alexander Hamilton's Ruminations From the Grave

Sometimes people report seeing the ghostly figure of Alexander Hamilton at City Hall Park. Dressed in an American Revolutionary uniform, he rallies his artillery unit, today the oldest American military unit, to listen to the Declaration of Independence—George Washington had commanded that this document should be read to the army on July 9, 1775.

Sometimes, Hamilton is reported being seen around his grave at Trinity Churchyard at 74 Trinity Place. Aaron Burr decided that Hamilton was responsible for his political ruin, though one could say that challenging Thomas Jefferson to become president of the country was even more suicidal. Burr challenged Hamilton to a duel on June 18, 1804. Hamilton accepted on June 20, 1804. Both men had been friendly at one point, where Burr had talked

Hamilton out of duel. We will never know why Burr fixated on Hamilton as the main source of his troubles instead of Jefferson and Washington. Both Burr and Hamilton made wills. Usually, only one duel in five ended in death.

Hamilton could have avoided dueling like George Washington by refusing to engage in the practice. Washington declared that the outcome was a matter of chance. He forbade Marquis de Lafayette under his command from accepting a challenge to duel on that basis. Abraham Lincoln, who talked himself into a duel, finally had the courage to apologize. By the time of the Civil War, politicians accepted that such rhetoric was partisan exaggeration and that fighting words would no longer result in an actual duel. They no longer took them to heart. For example, in the civil rights era, Senator Hubert Humphrey would make a pro–civil rights speech in which he would bitterly denounce Strom Thurmond. Next, Senator Strom Thurmond would then return the favor. Then, they would do lunch together and cooperate on other things.

Hamilton spent the night before the duel writing about how he had always been opposed to duels. Hamilton was the creator of his own mythology that he was apparently opposed to dueling following the fatal shooting of his son Philip in a duel in 1801. Before going to this confrontation, Hamilton rationalized in a letter that dueling was an obligation that a politician had to be willing to undertake in order to have credibility in public affairs. However, this was the tenth duel in which Hamilton had been engaged, and he provided the weapons as the challenged party.

The duel took place in Weehawken, New Jersey. One might hence ask, why not New York, since dueling was illegal in New Jersey as well as New York? Weehawken offered an ideal location that was small enough for duelists and hidden away from witnesses that might testify against this illegal activity. Other people were nearby but had plausible deniability that they had not witnessed the duel.

Then, 175 years later, the Smithsonian Institution, in borrowing the pistols from the Chase Bank Museum (Burr was their lawyer), discovered there was something unusual about the pistols. They had been specially ordered by Hamilton from well-known London craftsmen. The weapons had gun sights to make the weapons more accurate, which was against the rules. The Smithsonian also discovered that they also had a hidden mechanism to make the trigger pull a one-pound pull instead of the usual ten-pound pull, the custom to prevent the pistols from discharging accidentally.

What did Hamilton intend to do? The seconds of both parties agree to the events that took place, except the detail of whether Hamilton shot in the air.

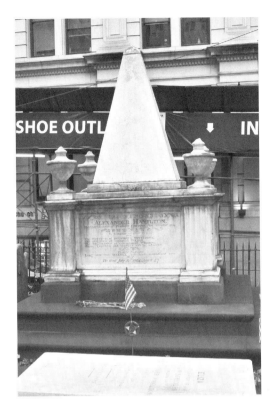

Alexander Hamilton stills haunts
from his grave at Trinity Church.

Did Hamilton intend to get off the first shot with the hidden mechanism?
Or did he trip?

Hamilton claimed that he did not intend to fire. He said that his pistol was
discharged accidentally as he fell. Further, Hamilton told the minister who
attended him as he lay dying, "I have no ill-will against Colonel. Burr. I met
him with a fixed resolution to do him no harm. I forgive all that happened."
Hamilton's death was very generally deplored as a national calamity.

Steve Tally in *Bland Ambition* thinks so. Richard Brookhiser in *Alexander
Hamilton, American* thinks that a depressed Hamilton committed suicide in a
socially approved fashion because of the death of his son Philip, therefore
concluding that Hamilton fired into the air. Burr himself testified that
Hamilton shot in the air.

Hamilton put Burr in an impossible situation. According to Thomas
Flexner, Hamilton planned to fire in the air, a maneuver in the duelist's code
known as a delope. William Pitt, the prime minister of England, had used
it in a recent duel on Hounslow Heath outside London. Its purpose was to
humiliate an opponent—to imply that he was not worth shooting.

What would have happened thereafter? This much is certain. If a successful Hamilton delope had been the outcome of the duel, the history of the United States, and the world, would have been very different. A humiliated Aaron Burr would have become damaged goods in American politics. No one would have paid any serious attention to him.

Hamilton, age forty-nine, died from one shot fired by Aaron Burr on July 11, 1804. The dying Hamilton was taken to his doctor's home at 27 Jane Street and then to his home "in the city" at 80 Jane Street, where he lingered to create his legend that he was always opposed to dueling. Strangely, he has never reported to have haunted his homes at Jane Street or in the country. His country home, the Grange, named after his grandfather's home in Scotland, was completed just two years before his death in 1802. John McComb Jr., the co-architect of city hall, designed the two-story Federal-style building. Perhaps Hamilton does not haunt his country estate because the building has been moved around a few times in Harlem.

Hamilton did haunt his former doctor's home at 27 Jane Street until it was torn down in the twentieth century. The subsequent householders that succeeded doctor's family would hear indistinct voices, and occasionally they would make a request for more water.

Gouverneur Morris, the drafter of the final version of U.S. Constitution, gave the eulogy at Trinity Church in which he declared that Aaron Burr had followed the dueling code correctly. Although Burr was never tried for murder by New York or New Jersey, he was found guilty by public opinion and his political career never recovered.

Edward Hyde, Too Soon for Gay Pride

Near the bronze bull at the Alexander Hamilton U.S. Customs House at 2 Broadway, be on the lookout for a most peculiar ghost—that of Edward Hyde, a.k.a. Viscount Cornbury. A cousin of Queen Anne, Hyde served as governor of the British colony of New York from 1702 to 1708. Hyde has the dubious distinction of probably being the worst governor the British ever sent to rule a colony. He was described as the worst possible combination of stupidity, arrogance and corruption.

When criticized for having opened the 1702 New York Assembly clad in a hooped gown and an elaborate headdress and carrying a fan, imitative of the style of Queen Anne, he responded that he was representing the Queen quite faithfully dressed as a woman! His wife was jealous that he had better

dresses and earrings than she did. I wonder if he exchanges fashion tips with Theodosia Burr.

The New York Historical Society has a painting of a man dressed in woman's clothing that some people claim to be of Edward Hyde, but there is no historical evidence to determine this.

Captain William Kidd Seeks His Revenge

Captain Kidd settled in New York in 1691, where he contributed his services to the building of the original Trinity Churchyard by providing a winch to lift the stones to build the church steeple. Kidd was a privateer, which was another way of saying that he was licensed by the English Crown to attack enemy ships during wartime and share any loot with the Crown and the crew.

Captain Kidd is one angry ghost, betrayed by his crew and friends in the English and colonial governments. They made him a scapegoat for piracy when he was hanged in 1701 in London. The government charged that he was supposed to be a catcher of pirates. However, Kidd was not permitted to defend himself. Now and then he walks off his anger on the grounds of Trinity Church, the one place that did not betray him and where he wished that he had been buried.

Mary Todd Lincoln Shops

Century 21 at 22 Cortlandt Street attracts ghosts in search of discounts. They were big spenders in their day; they now come back in search of bargains. Mary Todd Lincoln, sometimes in the company of the Astors or Vanderbilts from the nineteenth century, has been espied shopping there in the wee hours of the morning after the store has been closed for the day. Lincoln was the original person who shopped until she was dead from exhaustion. She managed to spend a $25,000 ($500,000 in today's money in a time when a good day's pay was $1 per day) appropriation that was supposed to last four years in one year to redecorate the White House. Abe Lincoln had the Republican Party come up with the money to avoid a scandal.

Wall Street Ghosts Take an Eternal Flyer

You might see ghosts wandering around Broad and Wall Streets. Stockbrokers and their customers jumping out the windows became a sad Wall Street tradition starting with the Panic of 1907. The New York Stock Exchange building opened at 18 Broad Street on April 22, 1903, at a cost of $4 million. The trading floor was one of the largest volumes of space in the city at the time, with a skylight set into a seventy-two-foot-high ceiling. The main façade of the building features a marble sculpture (*Integrity Protecting the Works of Man*) by John Quincy Adams Ward set in the pediment above six tall Corinthian capitals. Over the years, the New York Stock Exchange has expanded to occupy the entire block at Wall and Broad Streets. The numbers of ghosts seems to have increased because disappointed investors and their stock brokers keep on learning the same sad truth: "There is no new economic paradigm."

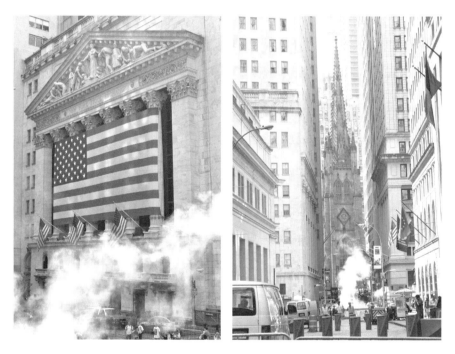

Above, left: Watch out for the ghosts that had committed suicide from the New York Stock Exchange's windows.

Above, right: Trinity Church is the center of ghostly activity in the Wall Street area. From 1846 to 1867, it was the tallest structure on Manhattan Island until the construction of the Manhattan tower of the Brooklyn Bridge.

Firms that have learned this the hard way are now just memories: White Weld, Bache & Company, Salomon Brothers, E.F. Hutton, Lehman Brothers, Merrill Lynch, Kidder Peabody and Kuhn Loeb.

General George Washington's Ghost Struggles to Say Goodbye

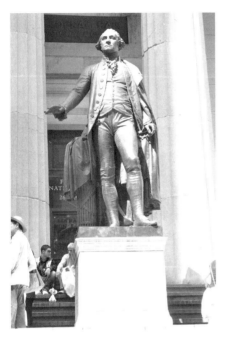

George Washington haunts his old stomping grounds where he served as general and president. The statue was erected in 1889 at Federal Hall National Memorial in honor of the centennial of his taking the oath as president at Federal Hall on 26 Wall Street.

Some claim that the specter of George Washington never left Fraunces Tavern at 54 Pearl Street, where he is still toasting his officers goodbye. When the last British soldiers left New York on November 25, 1783, George Washington felt that the American Revolutionary War had come to an end. This event was celebrated as Evacuation Day in New York City, until superseded by Armistice Day. Nine days later, December 4, General George Washington invited the officers of the Continental army to join him in the Long Room of Fraunces Tavern so he could say farewell. Washington filled his glass with wine. He turned to his officers and declared, "With a heart full of love and gratitude I now take leave of you. I most devoutly wish that your latter days may be as prosperous and happy as your former ones have been glorious and honorable." After shaking or embracing one another, his officers took him to Whitehall Wharf, where he was rowed over to Jersey City.

A few days later, Washington resigned his commission before the Contentment Congress in Annapolis, Maryland. The tired general told the politicos that they had entrusted him with great power for eight years—now he was returning it. He then went home to Mount Vernon; he thought he had retired from public life.

31

World Trade Center Ghosts Before and After 9/11

In 1972, the World Trade Center Twin Towers at Liberty and Church Streets became the tallest buildings in the world thanks to the foresight, vision and energy of three people: Austin Tobin, executive director of the Port Authority of New York and New Jersey, who mobilized its resources; Governor Nelson Rockefeller of New York State, who mobilized the political power; and his brother David Rockefeller of Chase Bank, who mobilized the business community.

World Trade Center Tower One had ghosts of its own before 9/11. Jerry E. Spivey worked as a night supervisor on the fifty-fifth to fifty-ninth floors once the World Trade Center opened. The ghosts of deceased partners would haunt people's dreams to tell them stop goofing off and back to work. He felt a premonition from these same ghosts telling him to leave the building on 9/11, a premonition that saved his life.

Following 9/11, there was no report of any ghostly activity even though almost three thousand people died. This held true until 2008, when the first reports of haunting phenomena began to appear. People have since reported seeing the spirits of the victims and the rescue workers, as well as the apparitions of the buildings. Several ghosts have been reported crying

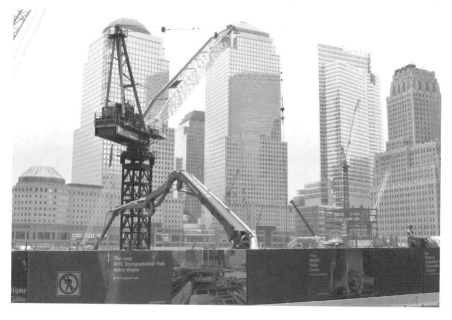

Hole in the ground—before 9/11, the Twin Towers had ghosts. Since this tragic event, ghostly activity has been reported.

out for help after 9/11. Although the new ghost central at Ground Zero has perhaps three thousand ghosts, it does not compare with the old ghost central: the twenty thousand ghosts inside Washington Square Park.

CITY HALL TRIBECA

The African Burial Ground National Monument: Exorcism Central

One of the greatest archaeological discoveries of the twentieth century is today the African Burial Ground National Monument at 290 Broadway. The excavations have shattered many stereotypes created by the failure to remember the past. It's a stark reminder that New York City was truly one of the major slave-trading ports of the New World. African slaves, rebellious Irish rebels and others were imported, while Amerindians were exported to the West Indies to prevent them from rejoining their friends and relatives.

Segregated in life, they were segregated in death from the 1690s to the 1790s at the African Burial Ground. They worshipped in the back of the white churches. In death, they were not buried in church graveyards of their masters but in the "Negro Burial Ground" north of the settled portion of the city. This included parts of present-day City Hall Park extending farther from Chambers Street to Duane Street, then known as the Collect Pond, a marshy area. Because their masters feared revolts, they could not gather in a funeral party bigger than twelve. Eventually, the burial ground was forgotten and paved over for real estate development in the early nineteenth century. By that time, an estimated fifteen thousand people were buried there.

In 1741, several slaves were executed via the gibbet on the common, today's City Hall Park, for taking part in the "Great Negro Revolt of 1741," though that revolt may have existed more in the imagination of the masters than in reality. For several years, numerous haunts were reported as if the executed slaves were trying to escape either execution or slavery.

When the construction of a new federal office building started in 1991, the burial ground was rediscovered. This time, the descendants of the slaves had a share in the political power. David Patterson, a state legislator at the time who became New York State governor in 2008, mobilized people in the community, black and white, to see that justice would be done. Archaeologists were called in to rediscover the story of these people. Two-fifths of those

buried were young children who died from burdens so heavy that they broke their bones. The white archaeologists thought that they had discovered a new disease when they observed the thickened wrists and ankles of the skeletons. The black archaeologists pointed out that this is where they had been chained. In 2008, a federal visitor center and monument opened at 290 Broadway. A memorial at Duane Street and African Burial Ground Way nearby opened shortly thereafter.

Since 1991, a series of exorcisms and prayer services for the souls of the departed have been sponsored by the federal government, some African nations and other groups. Several African nations have apologized that their ancestors took part in the African slave trade. As a result, the souls encased in the African Burial Ground are at peace. No more groans and moans are heard.

However, the nearby city-sponsored memorial, *Triumph of the Human Spirit*, by sculptor Lorenzo Place in Foley Square, has had the opposite effect because it was dedicated on Columbus Day, 2000, a politically incorrect day—it was Christopher Columbus who inaugurated the slave trade between the New and Old Worlds.

P.T. Barnum Still Humbugging Us

P.T. Barnum, the Walt Disney of his day, decided early in his life that he would make his fortune by making people smile. He became a success, and he did not drink, gamble, swear or womanize. He become rich, as did the people who worked for him. General Tom Thumb, the Chang and Eng Bunker Siamese Twins and George Washington's alleged mammy Joice Heth all made money. Barnum was the Ed Sullivan of his day, whether it was promoting the Fiji Mermaid or Jenny Lind, one of the great singers of the nineteenth century.

P.T. Barnum operated the American Museum at 222 Broadway just south of city hall from 1841 to 1865. Barnum succeeded in making his museum the talk of the town with its jugglers, ventriloquists, tableau, dancers and dioramas—a combination zoo, museum, lecture hall, wax museum, theatre and freak show all at the same time. It combined entertainment and education.

The American Museum in its day became the most popular attraction in America, as Disney World is today. At its peak, the museum was open fifteen hours per day, with one thousand visitors per hour. Like the good people

at Disney World, P.T. Barnum became a master at crowd control. He was famous for putting up a sign at what appeared to be another exhibition: "The Egress" ("Exit").

One of New York City's most spectacular fires occurred on July 13, 1865, and put an end to this museum. Animals fled from the burning building. This memorable scene was seen in the movie *Gangs of New York*. This was one of several fires that repeatedly destroyed his homes and various enterprises.

Since then, ghostly apparitions of his old exhibitions still walk the site. People occasionally see his ghostly figure still trying to put out the fire at the site of his museum.

Bridewell Haunts: The Poor and the Patriot

The Bridewell, designed by Theophilus Hardenbrook, was named after London's notorious Bridewell House of Correction. It was built in the city in the 1730s in the northwestern area of the present-day city hall park. The Bridewell, begun as a kind of workhouse, evolved into a jail and debtor's prison. During the American Revolutionary War, the British squeezed 800 American prisoners even though they had expanded the facility. Provost Marshal William Cunningham starved hundreds of prisoners to death because he sold their rations. He hanged 250 prisoners for protesting. Cunningham was finally executed when he tried to do the same thing to the British soldiers under him many years later. In 1999, when the park was being renovated, more than thirty skeletons were discovered in the northern part of the park, including a number of mothers and their children. Since then, the report of the number of haunts by the dead has declined. The ghostly groans of prisoners could be heard until the Tweed Courthouse, or the Old New York County Courthouse, was built in its place.

Alfred Ely Beach Built the First Subway in the New World

Alfred Ely Beach is not a ghost, but he was indirectly responsible for creating what appeared to be a haunt. He was the editor of the *Scientific American* newspaper (which evolved into the magazine of the same name) and was a patent attorney, too. In 1867, the Beach Institute was established by the Freedmen's Bureau with funds donated by Alfred

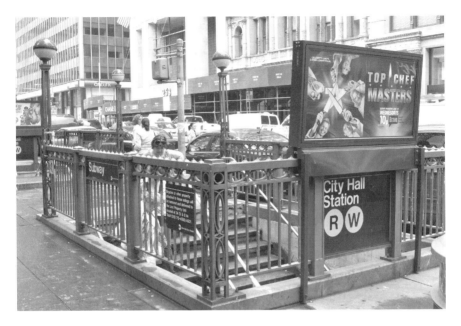

Alfred Ely Beach, the editor of the *Scientific American* newspaper, built a pneumatic-powered subway. He got permission to construct a mail tube, but he just did not say how big he would build it! When the R&W Line was excavated at this location, the original subway tunnel of Alfred Ely Beach was discovered here.

Ely Beach. It evolved into the Alfred Ely Beach Public High School of Savannah, Georgia.

People used to be able to hear Beach's pneumatic subway at night on Broadway and Warren Street. It was New York City's first subway, secretly built after the Civil War to avoid the machinations of Tammany Hall and William Tweed, representatives of the traction or trolley car interests. Alfred Ely Beach then received permission to build a pneumatic tube for the transit of mail. He just did not say how big it would be. The three-hundred-foot-long subway opened in 1871. The station even included a piano to entertain people. However, property owners such as A.T. Stewart opposed further construction of the subway. In 1873, the financial panic killed it off in favor of the elevated lines that were constructed. When the R&W subway line was built at the beginning of the twentieth century, the station was rediscovered. A giant fan was found that would occasionally turn and make eerie sounds. Nowadays, such a discovery would be preserved. Instead, photographs were taken and the old station was demolished to make way for the new one at the city hall.

Brooklyn Bridge Phantoms Still Taking a Toll

Walt Whitman, the editor of the *Brooklyn Eagle*, predicted that the city of Brooklyn someday would have more people than "that Gomorrah across the East River" if they ever built a bridge. And he was right!

Occasionally, the police get calls to rescue people threatening to plunge to their deaths off the Brooklyn Bridge ever since it opened in 1883. They then discover that the ghosts are those that had succeeded in jumping off. One police officer on the Brooklyn side of the bridge, when it was still a separate city, asked to be reassigned. He was tired of trying to prevent the same spirit from committing suicide on the bridge and unfortunately not succeeding.

Robert E. Odlum, a swimming instructor from Washington, D.C., was the first to jump from the bridge on May 19, 1885. He died upon impact because the water was like concrete at the rate of speed he was falling. He had wanted to gain fame and fortune but did not anticipate paying with his life. The Brooklyn Bridge was the world's longest bridge from 1883 to 1890.

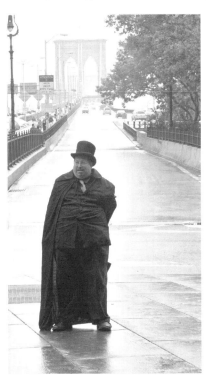

Dr. Phil checks out the spooks on the Brooklyn Bridge.

A year later, Steve Brodie claimed that he jumped off the Brooklyn Bridge to save a maiden from drowning. However, there were no independent eyewitnesses, and he did not repeat the feat. He did succeed in becoming the star of a hit play featuring the supposed jump and opened a bar, where he would retell the story if you bought him a drink. People suspected that a dummy was dumped off the bridge and that some waited around the bend in a rowboat. Hence, the phrase "to pull a Brodie" entered the English language.

The Brooklyn Bridge's deceased visitors have inspired many, like David Frango, whose acclaimed novel *The Ghost on the Brooklyn Bridge* summons "the spirit of Emily Dickinson as revealed through her poetry" to be the central ghost in his thrilling story. Boy, he must have some power to summon the reclusive poetess.

City Hall Apparitions Hard at Work Haunting

New York City's third and present city hall, built in 1812, is the oldest city hall still in use in America. At the time of its construction, it was a large building in its day. In 1958, the north side of city hall had its brick replaced by marble. Contrary to legend, the city fathers expected the city to grow north of City Hall Park and drew up a plan in 1811 that laid the streets and avenues north of Houston Street. They decided to build the north side in brick because it faced the poorhouse, the Bridewell at the time. Why should poor people have anything nice to look at?

At city hall, a maintenance worker quit because she was unable to fix the elevators that kept causing problems about midnight. Police officers and cleaning crews over the years have reported seeing ghosts dressed in nineteenth-century clothing in the basement where the city council press office is now located. The heartland of New York City bureaucracy gets the ghosts it deserves, nondescript ghosts.

City Hall Ghost Station, Still in Service

There is a "ghost station" at the original City Hall Station of the Interborough Rapid Transit Company (IRT), which opened in 1904. It was closed in 1945 when the length of the train became too long for the platform. Since another station, the Brooklyn Bridge Station, was only a few hundred feet away, it was cheaper to close down the City Hall Station than to attempt to modify it in any way. It is possible to see this most ornate, beautiful flagship station of the New York City subway stem if you get permission to stay on the No. 6 line when it makes a turn around the corner to go from downtown to uptown instead of continuing to be taken out of service.

The city has several such stations that are no longer in use because the platforms could not be made longer to accommodate the subway car length. The New York Transit Museum occupies such a facility in Brooklyn.

George Frederick Cooke Pioneered Headless Haunting

In life, George Frederick Cooke had his ups and downs. At one point, he packed two thousand patrons into the Park Lane Theatre opposite City Hall Park for a performance of *Richard III*. At a low point, he sold his own head

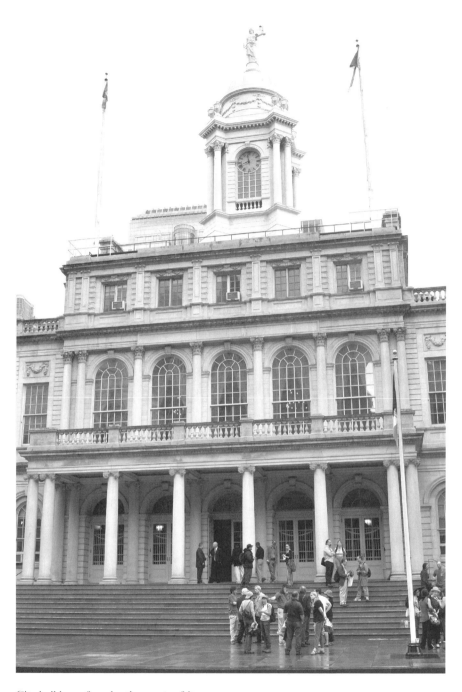

City hall has a few ghostly secrets of its own.

Since 9/11, the spirits have a view of the Hudson River once more from St. Paul Chapel's Graveyard.

(while it was still attached) so his mounting medical bills could eventually be paid. He was then buried headless on September 1811, having pledged his head to science. The flesh was peeled from his skull, and that skull was later used in theatrical presentations of *Hamlet*. Reportedly, Cooke's spirit as Hamlet roams the St. Paul Chapel's graveyard at 209 Broadway in a fruitless search for his missing head.

Gallus Mag, Bouncer Extraordinaire

Just under the Brooklyn Bridge, rumors continue of ghosts of the pirates who frequented the bar at 279 Water Street or disturb the second floor. This dates back to 1794, but the Bridge Cafe's life as a drinking establishment first began in 1847, when it was opened as a porterhouse, making it New York City's oldest bar according to its partisans. The partisans of McSorley's Old Ale House would beg to differ.

Gallus Mag, a six-foot-tall female bouncer, still seems to be devoted to her job after all these years. She specialized in biting the ears off drunks and keeping them as souvenirs. She filed down her teeth and wore brass

fingernails for combat. I wonder if she would win the contest as the ugliest bouncer ever. On more than one occasion, heavy footprints have been heard overhead from uninhabited rooms over the bar.

Abraham Lincoln Rocking Away

Before the Astor Office Building replaced the Astor Hotel in 1913, Abraham Lincoln could sometimes be seen rocking in a chair in his favorite New York City hotel. Lincoln now does his haunting at the Lincoln Bedroom at the White House or in Springfield, Illinois.

Before the Civil War, New York's most preeminent hotel was the Astor House at 207 Broadway, where Abraham Lincoln stayed before becoming president. The hotel had the city's first flush toilets. People who stayed at the hotel reported seeing a tall, gaunt figure roaming the hallway or rocking away on the porch before the hotel was replaced by the Astor Office Building in 1913.

Nearby city hall hosted his body for one day of viewing following his assassination, but he does not haunt there. Theodore Roosevelt's earliest childhood memory was watching the funeral procession from his grandfather's mansion at Union Square, where Whole Foods at 4 Union Square is now located.

Abraham Lincoln usually does his haunting in Springfield, Illinois, where he is buried, or at the Lincoln Bedroom in the White House.

Abraham Lincoln spoke at Cooper Union on February 27, 1860. He did pretty well. His sponsors sold 1,200 tickets for twenty-five cents each. They were able to recoup their costs, including his $200 speaking fee. At the time, that was the largest indoor space on Manhattan, with a capacity of 1,500. His "Right makes Might" speech helped get him the presidency, but he does not haunt there, either. You can still view the original podium that he used when he spoke inside the Great Hall.

The New York Times *Ghost, Colorless as the Newspaper*

When the skyscraper at 41 Park Row housed the *New York Times*, Mary Wilson worked as a reporter on the tenth floor in the 1890s. She kept finding that objects on her desk had been moved. At first, she thought it was her male colleagues, who might resent a woman encroaching on their turf. She set traps at her desk until she spotted a ghostly presence. This phantom is as dull as "the Gray Lady," the nickname for the *New York Times*. When the newspaper moved uptown in 1904, the staff left the ghost behind.

When the *New York Times* moved uptown in 1904 from 41 Park Row, it left behind a ghost. That is one way of solving a haunting problem.

Theatre Alley Headless Coachman Pioneers a New Fashion Trend

Theatre Alley near city hall became the first one-way street in Manhattan to facilitate the picking up of theatregoers at the end of their play before the Civil War. A violent fight between competing coachmen coming from different directions in the alley resulted in one coachman beheading the other! This inaugurated series of headless ghost tales in the area.

Bill Tweed, Still Active as the Spoilsman of Patronage

Bill Tweed is a ghost that cannot go away. The Old New York County Courthouse at 52 Chambers Street, renamed the Tweed Gallery and then renamed the Tweed Education Building, is his legacy. This building designed by John Kellum and Leopold Eidlitz (1861–81) was the first permanent government building erected by New York City after the completion of city hall in 1811. The courthouse was a grand Italianate monument with a long staircase facing Chambers Street. Architect John

Waite guided its recent restoration. People declared that Tweed had to be present because the reconstruction of the building took four times as long as the park did.

William Tweed was a crooked version of John Lindsey during his day. He kept his people calm during the Draft Riots in July 1863, so virtually nobody died in the Five Points. He had been the sponsor or cosponsor in the creation of the American Museum of Natural History, the Central Park Zoo, the lengthening of Broadway from Twenty-third Street to Eighty-eighth Street, the Metropolitan Museum of Art, Central Park, the Brooklyn Bridge and the design of the Upper West Side.

At one point, Tweed was held on a bail equivalent to what would now be $3 million! When he fled from jail, he was recaptured in Spain thanks to a caricature of him drawn by Thomas Nast.

Sometimes late at night, Bill Tweed, the boss of Tammany Hall, a Democratic Party political machine, can be seen striding the hallways of his crooked masterpiece now named in his honor. Between 1861 and 1871, he supervised the construction of the New York County Courthouse. The original cost of $250,000 zoomed to $7 million before scandal forced him out of office. When the scandal broke, the roof was not finished. As a result, it leaked until the 1950s, when it was finally completed.

Bill Tweed, Tammany Hall political boss, still calls the Old New York County Courthouse his home even though it now houses the New York City Department of Education.

Today, it is the home of the New York City Department of Education. The building is known as the Tweed Building, which is quite appropriate since Tweed had been involved in secularizing education. The *New York Times* crusaded against him when he got the textbook contract instead of them. His ghostly presence had been reported especially during times of scandal.

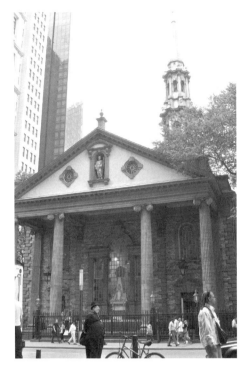

Left: St. Paul's Chapel has its share of spooks. The suburban chapel served those poor suburbanites unwilling to walk four blocks to Trinity Church or unwilling to pay the pew fees.

Above: The presidential seal indicates that George Washington may or may not have slept at St. Paul's Chapel, but he did worship at the chapel. Since then, he occasionally haunts.

President George Washington's Ghost Still Worships

George Washington as president worshiped at St. Paul's Chapel at 209 Broadway. Trinity Church had burnt down during the American Revolution. One of the reasons that we have so few old buildings is that we had such devastating fires in 1776 and then in the early part of the nineteenth century, before we designed the water system we have today. St. Paul's Chapel is the oldest public building in continuous use in Manhattan. It is also the oldest building in Manhattan still serving its original purpose as a house of prayer. Sometimes Washington's ghostly apparition has been reported seen in meditation.

Spirits of the American Indians Disturbed by the Coming of the Europeans

City Hall Park has, over the centuries, acquired many ghostly spirits. The Leni-Lenape had the village of Werpoes in the area. They believed in

one God only, but under him there were the manëtuwàk. These "lesser spirits" may not have been the same as the white man's angels, but they were at least similar (or they could have been likened to ghostly spirits). If a manëtuwàk was observed, a shaman would be called in to calm the spirit to make it go away. The Indians and their spirits have the right to be resentful since a lithograph tracing the history of City Hall Park starts with the arrival of the Dutch.

SoHo

Bishop John Dubois's Restless Soul

The original St. Patrick's Cathedral was at 263 Mulberry until it was replaced in 1858 by St. Patrick's Old Cathedral, designed by the Protestant James Renwick. John Dubois (1764–1842), the third bishop of New York, is buried below the entrance to St. Patrick's Old Cathedral. His ghost has been seen frequently inside the edifice. He cannot find rest because he is still looking to build a seminary to train priests, something that the diocese still lacked at the time of his death.

Mickey the Sailor Enjoys Life after Death

The building at 326 Spring Street that houses the Ear Inn was constructed in 1817. When the pub on the ground floor opened some time later, it quickly became a favorite spot for seafarers. In the middle of the twentieth century, Mickey the Sailor lived in the boardinghouse above the bar. He became a spirit when he was hit by car in front of the building. Martin Sheridan, one of the owners, claims that the apparition gooses the waitresses. The spirit gets even more amorous with guests brave enough to stay overnight. Supposedly, women who have lived upstairs above the bar say that the ghost has crawled into bed with them; bar patrons whose drinks inexplicably go missing blame Mickey the Sailor for drinking them. Mickey also earned his living as a television repairman. Now and then, unexplained noise comes from the apartment where he used to live.

Elma Sands's Curse Kills Two for the Price of One

The Manhattan Bistro in SoHo at 129 Spring Street is haunted by a young woman, Elma Sands. She announced that she was meeting her boyfriend Levi Weeks. Sometime later, Levi Weeks declared that he had called on her for a sleigh ride but did not find her at home. A few weeks later, in December 1799, she was found murdered and dropped in a well, which is now in the restaurant's basement.

The extremely wealthy Levi Weeks was defended in 1800 by the dream team of Alexander Hamilton and Aaron Burr, who attacked the character of the victim. Despite strong evidence, Levi Weeks was never convicted. Like O.J. Simpson or Lizzie Borden, the jury may have found him innocent, but public opinion did not.

Upon hearing the verdict, one of Sands's relatives called out a curse: "Alexander Hamilton, if there is any justice, you will not die a natural death." Four years later, Aaron Burr killed Hamilton in a duel.

Evidence of Sands's presence included ashtrays knocked off tables, plates being broken on the floor and bottles flying off shelves. Brett Watson, researching for one of his scavenger hunts, Watson Adventures, reported, "Sometimes people have spotted a young woman who is in a dirty dress with moss and vines on it," says Watson. "They say it's the ghost of Elma Sands."

Pierre Toussaint's Soul Seeks Beatification

Pierre Toussaint haunts the cemetery of the city's oldest Catholic church, St. Patrick's Old Cathedral at 334 Mulberry Street. He was a slave who became a hairdresser in the early nineteenth century. His master had fled from Haiti during its revolution. Toussaint was notable for works of charity among white and black folks alike. His spirit still haunts this location, although his body has been reinterred at St. Patrick's Cathedral uptown. Although the Catholic Church has beatified him, he needs another miracle or two to become canonized as a saint by the pope. Then perhaps he will stop his haunting.

EAST VILLAGE

The Astor Library, America's Most Popular Library for Ghosts

The Astor Library at 425 Lafayette Street has been haunted by three different individual ghosts: Austin Sands, Washington Irving and Joe Papp. John Jacob Astor, an immigrant from Waldorf, Prussia, had created his first fortune by cheating white settlers and Native Americans alike on the Columbia River. Before the War of 1812, his American Fur Company established the first settled American presence on the Oregon-Washington coast helping to secure America's claim to the Oregon Territory. Astor's private expedition also found a passage through the Rocky Mountains, facilitating the movement of Americans westward. He returned to New York to hire a literary flack by the name of Washington Irving to clear his name. The resulting propaganda tract, *A History of Fort Astoria on the Columbia River*, sought to show John Jacob Astor as a patriot and not a money-grubber.

Austin Sands, the miserly insurance executive, occasionally still likes to take in a good show at the Astor Library. The Astor Library was the first public library in the city though it was not a circulating library.

John Jacob Astor then went on to build an even greater second fortune in Manhattan real estate. He was the meanest miser in town and loved to foreclose on widows and orphans in hard times. At the time of his death, he had become America's richest man. He owned $20 million in Manhattan real estate when the entire assessed value of the island was $81 million. Astor declared that if he had known at the beginning what he knew at the end of his life, he would have bought up all of Manhattan Island. According to *Forbes* magazine in 2006, he was the fourth-richest man in American history, with wealth equivalent to $110 billion.

However, as John Jacob Astor lay dying, he took the advice of his good friend Washington Irving, and endowed a library with a small

fraction of his fortune, 0.5 percent, to give himself a good name. This would still have been equivalent to over half of one billion dollars in today's money! No ghostly activity was reported for ten years after he died in 1848. The library opened in 1854 thanks to efforts of the trustees, including Joseph Green Cogswell, book collector and librarian; Washington Irving, serving as the president; the writer Fitz-Greene Halleck, a well-known poet in his day; and Samuel Ruggles, the developer of Gramercy Park. The ploy must have worked because we hear of no haunting until 1859. Whether Astor is in heaven above or hell below, he is certainly not on this plane as a spirit. In 1859, a series of hauntings began. For this part of the story, dear reader, look up Austin Sands, Washington Irving, the HIAS ghosts and, finally, Joe Papp.

August Belmont Will Fill You with Spirit

August Belmont was born Elsass Schoenberg (no relation to me) in Germany, but he renamed himself August Belmont when he came to America in 1837. He had worked for the Rothschilds in Europe. His banking company became successful despite starting in the Panic of 1837. He married well because his father-in-law was Commodore Matthew Perry. He became active in national politics, becoming chairman of the Democratic National Party and minister to the Netherlands.

August Belmont would be displeased that the original city hall subway station was closed. He built the original New York City IRT subway line between 1902 and 1904. Belmont was in such a rush to finish construction that he was not above lending a personal hand in the actual labor. Sometimes late at night, he may still be heard fixing the subway system.

Belmont was so proud of what he had done that he had the world's only private subway car, called the Mineola. August Belmont would ride his private subway car from Grand Central to Belmont Racetrack in Queens. If you are not careful, come springtime, when the ponies are running in Belmont, you might find that August Belmont will pick you up in his private subway car on the way to the Belmont Racetrack on Long Island. Astor Place and city hall subway stations are his favorite places to pick up unwary passengers to take them to the Belmont Racetrack. It is a fabulous bar car, in which the lucky passengers enjoy the drinks. By the time they arrive at Belmont, the passengers are certainly full of spirits. Best of all, there is no tab!

The Bowery's Homeless Ghosts Find a New Home

The Bowery Bar and Restaurant at 358 Bowery is ghost central for homeless ghosts of the area known as the Bowery. Once McGurk's Hellhole was knocked down at 295 Bowery, the ghosts were forced to find a new home. One hundred years ago, the lowest of the low prostitutes would commit suicide at McGurk's bar. This turned the bar into a ghastly tourist attraction that competed with the Tivoli, the Harp House and the Cripples' Home.

The Bowery Hotel, opened in February 2007, has several specters that still lodge in its rooms and that never checked out. Some people book rooms in hopes of seeing the specters or of those of the nearby New York Marble Cemetery.

Bowery Hotel Phantasms Are a Tourist Attraction

I have a guide in my employ, Jamie Owens, whose day job (and sometimes night job) is working the front desk at the Bowery Hotel at 335 Bowery. It is built over and next to a graveyard, the New York Marble Hill Cemetery. Employees working the nightshift report that the elevator inexplicably gets stuck in the early morning hours, or else it creaks and makes strange noises. Other electrical problems are apt to occur between 1:00 a.m. and 2:00 a.m. A woman in a white dress with brown eyes specializes in haunting the second floor. One of the security guards realized after a conversation that he had been talking to a ghost! People book rooms on the second and third floors in hopes of having ghostly encounters or seeing phantoms in the graveyard.

Charles Dickens recites A Christmas Carol *in America*

No, Charles Dickens is not a haunt in America. Charles Dickens was one of the greatest writers of all time because he was both a marketing and communication genius, according to Professor Elliot Engle of Duke University. The British author sold the same book three times. As an

The Empire State Building (background) built in 1931 and Cooper Union (foreground) built in 1858 have one thing in common: ghosts.

unknown, he was approached to write "filler" material between pictures of a well-known illustrator. He explained to the publisher a marketing plan that he had thought up. They followed it to the T. First, *The Pickwick Papers* came out in the form of a serial newspaper publication. Dickens proved that he possessed such literary talent that what he wrote became more important than the pictures. Just as the book was coming to an end, people were asked if they wanted to buy the trade market edition at a discount if they handed in the newspaper version printed on poor-quality paper. Then, after people bought the trade book edition, they were asked if they wanted to buy the "collector's edition"—the newspaper edition put together with a quality cover—three book sales in one.

Charles Dickens was also the father of the soap opera. He would write three chapters with a problem to be resolved. He caused the first traffic jam in New York when pedestrians were unable to move as they were awaiting the latest news from *Oliver Twist*! When an English ship would dock, the crowd would shout out, "Does she yet live!?"

Dickens even sparked the invention of fast food. When he came to America to read his work in 1842, he was the superstar of his day. Crowds lined up for days to buy tickets. An enterprising restaurateur in Philadelphia decided to bring food to the people to buy since they were not coming to him.

Upon his return to America in 1867, Dickens read *A Christmas Carol* at Cooper Union in 1867. In the audience was Samuel Clemens on his first date with his future wife, Olivia "Livy" Langdon.

Both Clemens and Dickens aroused the ire of publishers of the time by demanding royalties. Because of the peculiarities of copyright at the time, American authors found it hard to get English copyright and English authors American copyright. Washington Irving was the first American author to make this an issue.

New York City Fire Ladder Company 33 was established in 1865 when New York organized the country's second professional fire department after Cincinnati. The building at 44 Great Jones Street, designed by Ernest Flagg in 1898, has its own ghost in residence.

Fire Company No. 33 Apparitions Trying to Rest

In 1898, Ernest Flagg originally designed 44 Great Jones Street to be the New York Fire Department Headquarters, as well as a firefighting station. Rumors are rife that a dead colleague keeps paying a visit. One firefighter thought that an off-duty comrade captured what he thought might be a ghost on his mobile phone. Another firefighter believes that these ghosts are shadows of past firefighters trying to get some shut-eye when he tries to do the same. Great Jones State Street got its name when Mr. Jones donated some food for land. Since there was already Jones Street, someone on the city council suggested adding "Great" to the name.

HIAS Ghosts Moans and Groans of Ghostly Immigrants

Between 1920 and 1960, Hebrew Immigrant Aid Society (HIAS) occupied the Astor Library building at 425 Lafayette Street. It had been founded on the Lower East Side by three landsmanschaft (self-help groups) in 1903. In 1927, HIAS merged with two other Jewish migration associations—ICA

Sometimes groans and moans are heard in the offices of the Astor Library when this served as the offices of the Hebrew Immigrant Aid Society. If you look carefully, you make out its initials: H-I-A-S.

(Jewish Colonization Association), sponsored by British and French Jews; and Emigdirect, supported by German Jews—to form HICEM. The name HICEM is a combination of HIAS, ICA and Emigdirect. If you look carefully on the north side of the building, you will see painted in black the letters H-I-A-S. Since the renovation of the Astor Library by Joe Papp in the 1960s, the security guards report that they hear the cries of distressed individuals in a host of languages but never find anybody in the rooms.

Matilda Hoffman, Washington Irving's Fiancée

Washington Irving's "lost sweetheart" Matilda Hoffman haunts the grounds of St. Mark's Church in the Bowery in the East Village at 131 East Tenth Street. The seventeen-year-old miss was engaged to marry the twenty-year-old Washington Irving, but she died in 1809 before the wedding could take place.

Harry Houdini, Ghost and Ghost Buster

Harry Houdini is one interesting ghost. If you see a cat inside the window at McSorley's Old Ale House at 15 East Seventh Street, this indicates that he is present as a ghost at his favorite bar. I had someone on my tour who said, "When I was young and stupid and had too much to drink, I got thrown out of the bar by Harry Houdini himself. There was no one else around

to explain this." There are three pairs of handcuffs in the bar, one on the railing down below and two near the ceiling. The one pair that is chained around a tin lamp is his own.

Harry Houdini initiated the anti-séance and anti-medium crusade because he felt that people were being preyed on by these charlatans who claimed that they could get in touch with their loved ones. Many people had lost dear ones because of World War I or the great influenza epidemic that followed afterward. It was a great publicity gimmick, as well. When the mediums declared that his mother had forgiven him for marrying out of the Jewish faith, he would show a photograph of him and his wife together with mom, or he would say that dear old mom did not know any English in her life.

Arthur Conan Doyle's second wife, Jean Leckie Doyle, was an amateur medium who channeled Mrs. Cecilia Steiner Houdini (1841–1913), the mother of Harry Houdini. When Houdini questioned how his mother could speak English, Arthur Conan Doyle declared that she must have gone to college in the afterlife! Doyle and Houdini, once friends, parted ways.

A claim has been made that he was done in by the spiritualists who resented losing business—or perhaps one of their curses worked. An autopsy taken upon the request of his nephew produced no evidence of foul play. Harry Houdini did die on Halloween 1926 because he had neglected to take proper care of himself. He died of appendicitis, which could have easily been cured if he had seen the doctor earlier when the symptoms developed.

His wife Bess, for about ten years, undertook the "Houdini Séances" shortly after her husband's death. They were held frequently at the beginning, until they became an annual event held on Halloween. Every Sunday at the hour of his death, she would shut herself in a room with his photograph and wait for a sign or for a message from Houdini. Arthur Ford announced that he knew the message: "Forgiven."

At first, Mrs. Houdini gave credence to his claim, until friends pointed out that a book published the year before had mentioned this detail. Other books had been published that disclosed how he did his mind reading tricks. The secret of being a great psychic is great research.

The last effort was made on Halloween 1936 at the Knickerbocker Hotel in New York City. Bess finally ended the effort at contacting her husband by mournfully declaring on a radio address heard around the world: "Yes, Houdini did not come through," she replied. "My last hope is gone. I do not believe that Houdini can come back to me—or to anyone. The Houdini shrine has burned for ten years. I now, reverently…turn out the light. It is finished. Good night, Harry!"

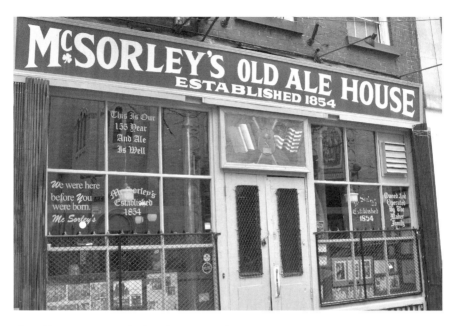

Above: If cats are present in the window at McSorley's Old Ale House, it means that Harry Houdini may be present as a bouncer or even inside the cat!

Below: These are Harry Houdini's handcuffs that he left at his favorite drinking establishment, McSorely's Old Ale House.

Once again, you have to remember that there is no real mystery about how Harry Houdini performed his tricks. You do have to remember that Harry Houdini also made his living by sharing his secrets—for a fee, of course—with his fellow professionals. He owned America's largest magic shop. He wrote books on how he did his magic tricks. He had a younger brother who performed his tricks on the same vaudeville circuit under the name "Hardeen." In turn, his son, Harry's nephew, also learned them. They continued to perform decades after his death. Finally, Houdini was also president of the Society of American Magicians.

You cannot keep a good ghost down! In March 2007, descendants of the families of Harry Houdini and Margery Crandon, a spiritualist who was alleged to have poisoned him, supported a move to exhume the body in the interests of determining the historical truth. So far, nothing else has been heard from this action.

Washington Irving's First Reported Appearance as a Ghost

Washington Irving, America's first professional writer, was the first American not only to earn a living from writing but also to gain international fame from it. Irving encouraged authors such as Nathaniel Hawthorne, Herman Melville, Henry Wadsworth Longfellow and Edgar Allan Poe to follow in his footsteps. Poe sought Irving's comments on "William Wilson" and "The Fall of the House of Usher." Irving was also an advocate for stronger copyright laws—a crusade that Charles Dickens and Samuel Clemens would join.

Irving wrote haunted tales set in America, England, Germany and Spain. He is best known for his short stories "The Legend of Sleepy Hollow" and "Rip Van Winkle," both of which appeared in his book *The Sketch Book of Geoffrey Crayon, Gent.* Many admirers, including Charles Dickens, considered him the father of both the American and English ghost stories.

Washington also wrote biographies of George Washington, Christopher Columbus and Muhammad. In January 1828, he published *The Life and Voyages of Christopher Columbus*, the first project to bear Irving's name instead of a pseudonym. The book was popular on both sides of the Atlantic Ocean. Irving popularized the myth that Christopher Columbus was convinced that the world was round while everybody else though it was flat.

Irving became a friend and advisor to John Jacob Astor in writing his book *A History of Fort Astoria on the Columbia River*, which glorified what the fur trade had done. In 1848, he convinced the dying Astor to set aside some

money to create a library to the public, the Astor Library. Irving became its president. After Irving died in 1859, he began to haunt the Astor Library.

A few months after dealing with Austin Sands, the first Astor Library ghost, resident Astor librarian Dr. Joseph Green Cogswell found late at night that he had another specter on his hands. He encountered Washington Irving in the library. It was quite a shock to him because the writer had died a few months before in November 1859. Having some ghostly experience now, Cogswell approached his old boss, Washington Irving, the president of the Astor Library, to inquire what he was doing. Washington Irving explained that he was completing some research. He promised to stop haunting once he finished his project. He was as good as his word, and after a few weeks he stopped haunting the library.

Washington Irving Found a New Location for His Ghost Activities

Instead, Irving began to haunt next door at the Colonnade at 428–434 Lafayette Street. It is too hard to believe that this still badly dilapidated building was America's first home for the super rich. It had been built on the

Washington Irving haunts the Colonnade, where he once lived. This was the first apartment building for the super rich instead of having a mansion. Part of the original structure was torn down to make way for a warehouse.

city's fanciest street, then Lafayette Court (closed off in the early nineteenth century, today Lafayette Street), named in honor of Marquis de Lafayette. The building was modeled after the American Revolutionary patriot's country estate. Irving's presence has been reported there several times. It was built shortly after Marquis de Lafayette's visit to America (1824–25) upon the invitation of Congress.

Washington Irving's brother Pierre claimed to have seen Washington a few times at Washington Irving's home, Sunnyside, in Tarrytown, Westchester, north of New York City. The former Dutch farmhouse overlooks the Hudson River. Of course, with all the money he made from his writings, it was no longer just a humble farm cottage.

Lucky Luciano Gets with Today's Music

The East Village Music store at 85 East Fourth Street has a long history of hauntings, starting when it served as Lucky Luciano's Palm Casino in the 1920s. Charles "Lucky" Luciano (born Salvatore Lucania) got the nickname "Lucky" because he failed to become a ghost after taking a "ride." The scar above one of his eyes was a permanent testimony to his fortunate break. Occasionally, the gangster makes a guest appearance even though he was deported from America and buried in Italy. Along with Meyer Lansky, he is considered the father of modern organized crime in America. Luciano also stressed the importance of the omertà, the oath of silence pioneered by earlier gangsters. Apparently, Luciano has no trouble with today's music scene, as he shops for the latest music.

Edna St. Vincent Millay Writes a Poem in Honor of a Ghostly Encounter

Edna St. Vincent Millay, the poet, spotted a ghost at 139 Waverly Place when she lived there with her sister, Norma. She put her experience to poetry, writing "The Little Ghost." Her mother had given the middle name of St. Vincent in honor of the hospital that had saved the life of her uncle. Millay also worked as a librarian.

New York Marble Hill Cemetery Phantoms

The New York Marble Hill Cemetery is located behind the Bowery Hotel, the interior of the block bound by East Second and Third Streets, Second Avenue and the Bowery. At the time, this area was just farmland. This should not be confused with the nearby New York City Marble Cemetery, which is entirely separate and was established one year later. In 1830, the city's oldest nonsectarian cemetery was set up. The cemetery was designed to be in compliance with recent public health legislation that had outlawed earthen burials. The half-acre of grounds contain 156 underground family vaults the size of small rooms beneath the grass lawn. There are no monuments or markers above ground. People book rooms in the Bowery Hotel in hopes of seeing ghouls from the cemetery; perhaps Aaron Clark, the Whig mayor, wants another term in office, or Luman Reed, the foremost patron of the arts in New York City, wants to continue collecting art. The residents, however, seem to be usually at eternal rest.

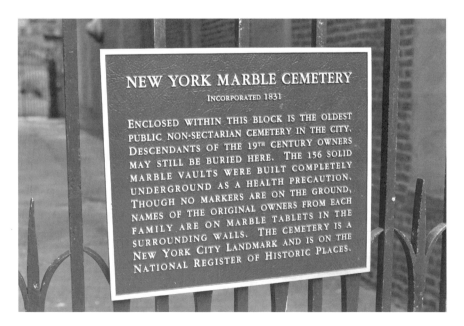

Ghosts like to lodge at the Bowery Hotel when they are overbooked at the nearby New York Marble Hill Cemetery.

Joe Papp, Ever the Stand-up Guy or Ghost

In addition to Austin Sands and Washington Irving, we have the presence of a third ghost, Joe Papp, in the Astor Library. The actor, director and producer received permission to perform Shakespeare in Central Park to popularize the bard in 1957. Then he restored the Astor Library in 1967 to produce innovative playwrights. Joe Papp was a standup guy that told the House Un-American Activities Committee (HUAC) exactly where to go in the 1950s. Since his death in 1991, he has been reported encouraging the actors and anyone else involved in theatrical productions on opening night. They don't recognize him at the time but realize it is him afterward. Apparently, he just can't let go of the theatre.

Edgar Allan Poe's Favorite Drinking Establishment in This or the Next Life

Edgar Allan Poe would booze it up with his buddies at the bar in the building at 47 Bond Street. Sometime he would go down to the cellar, which seems to have inspired him to write several stories involving people or animals locked or sealed away, such as "The Cask of Amontillado." Ever since, the wait staff has reported unopened wine bottles half-empty. The only logical conclusion is that Poe has found a great place to indulge! I lead a tour there on which I learned a new term, "orb"—an unexplained source of light that appeared in a photograph we took down in the cellar.

Poe's spirit has its favorite parks. His spirit has been seen strolling Washington Square Park and St. Luke's playground. Once in a while, he has been spotted at his favorite place from which to look at the Hudson River, a rock off Eighty-fourth Street. Edgar's Café is supposed to be located where the living room of the farm that he rented was located on Eighty-fourth Street.

Speaking of colleges, we might as well mention Poe's connection to Fordham University. He moved to a cottage in the Fordham section of the Bronx, New York. He enjoyed walking and talking with the students and Jesuit faculty of nearby St. John's College, now known as Fordham University. College folklore claims that its bell tower inspired him to write "The Bells." His wife was attended by Mrs. Shew, who arranged her funeral when she died in 1847. The Poe Cottage, administered by the Bronx Historical Society and moved to a city park when a street was put through, is located on the

Dr. Phil looks forward to having dinner with the spirit of Edgar Allan Poe at Il Buco Restaurant at 47 Bond Street.

southeast corner of the Grand Concourse and Kingsbridge Road and is open to the public. Occasionally, his haunting presence has been reported. The site is definitely worth a visit.

Theodore Roosevelt Jogs to Law School

It can be said that Theodore Roosevelt scared the New York police into being honest and diligent. Actually, as an urban reformer, he replaced the culture of corruption—Tammany Hall sleaze, favoritism and laziness—with the culture of professionalism, diligence, courtesy and merit. As president of the four-member New York Police Board, he was the spokesman. He pioneered the use of pistol shooting ranges to improve the ability of the police to shoot straight and introduced the flying bicycle squad when bicycles were state-of-the-art technology and the promotion on the basis of merit. Energetic, he would see if police were on the job late in the evening and early in the morning. Schoolchildren would buy models of his teeth to scare police officers in the dark. As governor, he signed a bill that put one police commissioner in charge instead of a police board in 1901. Once he became police commissioner, he always wore a pistol on his belt, even when he was president.

On nice spring days, you can see a young Theodore Roosevelt jogging to complete Columbia University Law School at 55 Great Jones Street. His political career took off and he never completed his degree. When he became vice president, he began the study of law because that was considered a career dead end. The assassination of William McKinley changed all of that, and the rest is history as they say. He loved to tell ghost stories to his children. He has clearly earned the title as New York City's most athletic ghost.

Austin Sands, the Cheapskate Ghost

If John Jacob Astor had been the meanest miser in Manhattan, then Austin Sands, an insurance executive, ran him second. He is the first of three individual ghosts to haunt the Astor Library. I'll retell my own version of this story that I first found used in *New York City Ghost Stories* by Charles J. Adams III. He mined the diary of George Templeton Strong (1820–1875) for this story. Strong graduated from Columbia College in 1838. He then joined his father's law practice that evolved into Cadwalader, Wickersham & Taft, which is today the nation's oldest operating law firm. His 2,250-page diary, discovered in the twentieth century, gives us an intimate account of the doings of the city by member of the elite. In several entries, he tells us about the presence of the first ghost to haunt the Astor Library.

In 1859, Dr. Joseph Green Cogswell's sleep began to be disturbed by noises he heard next to his bedroom. Finally, he approached Washington Irving, the president of the Astor Library and the author of many a ghost tale. Dr. Cogswell said to Washington, "You are a ghost expert. Tell me what to do." Washington suggested getting the meanest dog they could find and then putting him in the bedroom from which the noises were coming. They did. The next day, they opened the door and the dog fled, never to be seen again.

Finally, Dr. Cogswell spotted the ghost, blasé, tired and blue, at Shelf B30 in the library. It was the late Austin Sands, an insurance executive, who had done John Jacob Aston one better by giving nothing to charity. Dr. Cogswell challenged the ghost by demanding, "Sir, will you pay my overtime?" The miserly ghost became embarrassed. It did not want to pay the doctor for his time. It was glad to try the vanishing dodge, and it silently vanished away. However, Dr. Cogswell's experience made him nervous and shaky.

The bold Austin Sands still returns from time to time to catch a free show when the productions are not sold out. People feel his presence, as the temperatures drops when the ghost watches from a seat.

Strange Shadows at St. Mark's Church in the Bowery

St. Mark's Church at 131 East Tenth Street is the fourth-oldest building, after St. Paul's Chapel, the Morris-Jumel Mansion and the Dyckman Farmhouse, on Manhattan Island. The cornerstone was laid in 1795. The church opened for worship in 1799.

St. Mark's Church in the Bowery rents out some rooms in the rectory that once served as the homes for Episcopalian monks and nuns. A writer that took our tour in September 2007 reported that her apartment in the rectory is haunted. When she moved in, her dog, a Yorkie, became frightened and stopped going into one room unless she was present. Occasionally, she reports seeing the shadows of people even though nobody is present in the room.

Alexander Turney Stewart Does Not Wander Anymore

In life, A.T. Stewart had been a pioneer department store magnate. His store had goods arranged by department, hence the name, with trained sales clerks who knew something about the stuff. He also had odd prices at times, not so much to make consumers think that they were saving money but to force his cashiers to make change and put the money into the cashier box so that he would not have them as "partners." He was so successful in building what was then America's biggest department store that he was able to send a whole shipment of food to Ireland during the "the Great Hunger."

Stewart died on Columbus Day, 1876, and was buried in the family mausoleum at St. Mark's Church in the Bowery. Two years later, his body was snatched. His canny widow bargained down the ransom demands from $200,000 to $20,000. The body was then hidden at his department store on 280 Broadway (north of City Hall Park) until the Episcopal Cathedral of the Incarnation in Garden City, Long Island, was completed in 1884.

There he is buried now, under a few tons of concrete. Passersby occasionally reported seeing his ghostly presence at the church and store until his reburial. Apparently, he is now at peace. The family mausoleum in the churchyard has fallen into decay. The chief of police, George Walling, who led the Stewart investigation, recounted that if the vault at the cathedral is to be disturbed, a hidden spring will be released, causing all the bells in the cathedral's tower to ring out as an alarm. Perhaps this will be loud enough to wake the dead.

Peter Stuyvesant, New York's Oldest Ghost

Peter Stuyvesant pioneered the haunting business in New York upon his death at the very ripe old age of eighty in 1672 at his mansion of what is today the corner of Third Avenue and Eleventh Street. He is also unique in that he successfully transferred his ghostly activities to another location when the old one no longer proved to be suitable.

Stuyvesant had been the last Dutch ruler of New Netherland as the governor general. He had lost his leg fighting the Spanish in the West Indies. He was put in charge of the struggling colony on Manhattan Island whose fortunes he successfully revived. He expanded the colony of New Netherland to its greatest extent. He conquered New Sweden (Delaware) in 1653. Stuyvesant also built a wall around the city that was known as Wall Street. He founded both the New York City Police and Fire Departments.

In 1664, Stuyvesant was downsized out of his job by the English, who wanted the colony. The Dutch did not think it was worth fighting for. But don't feel too sorry for him. He had already given himself a very golden parachute, Bowery Farm No. 1, the best three hundred acres of farmland on Manhattan Island, the East Village from the East River to Fifth Avenue and from Fourteenth to Twenty-third Streets. His descendants would always be the richest or the second-richest family on Manhattan Island until the male side died out. He became good friends with the English governor who succeeded him.

Upon his death, he began haunting the family mansion. He specialized in scaring the servants into dropping and breaking crockery and pottery. One of his daughters claimed to have seen dear old papa. This continued to be a favorite pastime of his until the family manse burned down in 1744; he relocated his ghostly manifestations to the cemetery where he was buried. Family and friends claimed that they spotted a ghostly figure with a peg leg sadly inspecting the remains of the family manse upon that occasion.

His grandchildren donated the family graveyard on condition that the Stuyvesant family vault be made part of the church. Alexander Hamilton was the lawyer responsible for the legal incorporation of the church. He was shortly due to become a ghost himself. Perhaps Stuyvesant knows no peace because he is a good Congregationalist now buried in an Episcopalian churchyard!

Peter Stuyvesant resumed his haunting in 1831 when the city put Second Avenue through the family farm. He did his best to scare the workmen off, but they stood their ground. When Second Avenue was broadened about

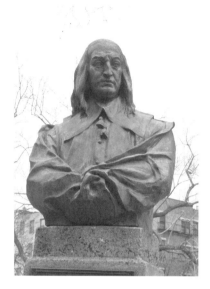

Left: Bust of Peter Stuyvesant surveys his haunted domain at St. Mark's Church in the Bowery.

Below: Plaque of the Stuyvesant family mausoleum, where America's oldest ghost, Peter Stuyvesant, is still active as a haunt.

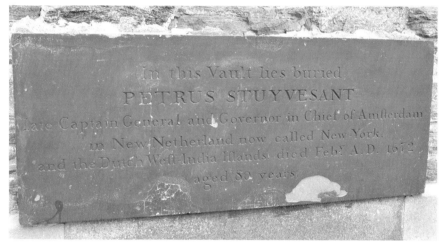

1900, Peter Stuyvesant once more tried to scare off the workmen, but again they stood their ground.

The highlight of his nineteenth-century manifestations was the ringing of the church bell on Good Friday, April 14, 1865. The rector of the church rushed out to investigate who was ringing the bell. He spotted a ghostly figure with a peg leg in Dutch period costume running away. What amazed everyone was that the bell rang without the rope. The bell rope had been cut away a few days before. The next night, the bell rope was spotted on the Stuyvesant family burial vault.

If you recognize the date of this church bell incident, that is because it was the date of Abraham Lincoln's assassination. Apparently, he was welcoming the Great Emancipator into the heavenly firmament. Stuyvesant had forty slaves to run his plantation but had freed them upon his death, and they were buried in the family vault with other members of the Stuyvesant family.

In the 1930s, an Episcopalian priest observed that a certain young man always sat in the same corner and stared intently in his direction when he gave his sermon. He finally asked the young man what he was looking at. The young man explained that when the priest gave the sermon, he observed a man in Dutch period costume with a peg leg sitting nearby with a lady also in Dutch period costume. Apparently, over the centuries, Stuyvesant acquired a girlfriend.

In 1954, the last direct male descendant bearing the family name of Stuyvesant died. He and two sisters were too hoity-toity to marry anyone. He used to visit his famous ancestor every Sunday for hours at a time to commune with his ancestor's spirit. At his funeral, some of the attendees claimed that they heard what appeared to be rapping of a peg leg as if greeting him when he was interred in the family vault. Many thought this would be the last they would hear or see of the ghost of Peter Stuyvesant.

However, on Christmas Day 1995, the congregation upon the conclusion of services heard "One hundred bottles of rum, ninety-nine bottles of rum, etc." When they rushed into the room set aside for refreshments, they observed a figure in Dutch period costume and with a peg leg disappearing into the wall. They saw that the punchbowl was down an inch.

I had someone on my tour shortly before Halloween 2003 who said that she had attended late-night services. When she left the church, she began to hear what appeared to be a peg leg behind her. She ran all the way home without stopping or turning back. You can't keep a good ghost down.

The Tredwells: The Saddest Ghost Family in New York

The Tredwells are New York City's saddest ghost family because they all haunt separately at the Merchant House at 28 East Fourth Street. The mansion, built from 1831 to 1832 by Joseph Brewster, was purchased by Seabury Tredwell in 1833 in order to move his family away from the bustle of the South Street seaport, where he worked as a successful hardware merchant. He also owned a farm that occupied most of the Upper West Side. Over

the years, many stories of intrigue and family mayhem have been told. The family occupied the premises for a century until Gertrude died a spinster in an upstairs bedroom in 1932. Her two cousins who inherited decided to turn the house into a museum. It is the only nineteenth-century house complete with contemporary furnishings in Manhattan. Claims have been made that this dwelling is Manhattan's most haunted house, with numbers of ghosts estimated between four and forty! As we shall see, we have five sisters, all spinisters, who are ghosts. They had three brothers who married and never became ghosts.

Eliza Tredwell is active in the bedroom of her childhood. In the 1950s, two caretakers who boarded at the house reported gentle tapping on the wall behind their headboards coming from a room adjacent to theirs. They were the only ones there at the time. Occasionally, the docents report that the sheets in the bedroom appear to be undone when in the morning.

Sarah Tredwell's suitor was rejected by her father, who felt he was far inferior socially. Unfortunately, she was in the family way. Upon the birth of her newborn baby, her father allegedly ordered it killed and buried in the cellar. Sarah then heard cries of the baby she was forced to give up. Seabury Tredwell ordered the servants to find the corpse, but they were not successful. Then Sarah committed suicide. A pall of gloom settled over the family and life in the Tredwell home.

Phoebe Tredwell simply fell down the staircase and died. Docents reported feeling very uneasy or experiencing a loss of energy when they came to the top of the stairs. A full apparition was reported in the late 1930s when a wispy figure dressed in Victorian clothing descended a staircase and looked in on a woman who was cataloguing Phoebe's wardrobe.

Gertrude's sister, Julia Tredwell, is the piano-playing ghost. The Fischer piano in the parlor has been heard playing with no human hands anywhere near. The only problem is that the piano is broken.

Gertrude Tredwell, the youngest of the sisters, was born here in 1840. Gertrude's ghost is most often spotted in the kitchen, though she's also been seen in her bedroom, appearing as an elegant, petite woman dressed in mid-nineteenth century style. Margaret Halsey Gardiner, the museum's executive director, compares Gertrude to the character of Catherine Sloper in Henry James's *Washington Square*, who was forced into spinsterhood by her domineering father. Gertrude lived a similar tale. She was the youngest of eight children of Eliza and Seabury Tredwell. According to the family's history, Gertrude fell in love with a doctor, Lewis Walton. But her father, an Episcopalian, forbade her to marry Walton because he was Catholic, Irish and poor.

After Seabury Tredwell died in 1865, Phoebe and Gertrude lived together in the big house. Little daylight ever entered the rooms, and the sisters waited until after sunset to go outside. Upon the death of Julia in 1909, Gertrude remained alone in the family homestead for twenty-four years, always obsessing over keeping the house the same in the rapidly changing world around her. Because of that determination, the home was already in near museum-quality condition the day she died alone and impoverished in the bed in which she was born. Some people say that old Gertrude—known as "Gerty" in her younger years—still keeps a close watch on the brownstone in ghostly form.

Three years after Gertrude Tredwell died, the house was turned into a private historic site and museum. Those who traipse through the stunning, four-story mansion may catch a glimpse or feel the presence of Gertrude's ghost. The thought that Gertrude's spirit remained within the walls of the house first came to light when architectural surveyors and researchers reported untoward experiences as they worked inside.

Docents or interpreters of the house claim that they have been possessed by Gertrude's spirit and have done automatic writing. A former volunteer guide in the historic site once reported that she sat at a table in the kitchen with a pencil in her hand. She then felt a strong force guiding her hand to involuntarily write—not in her own handwriting but in the classic style of longhand, which is largely long gone—the words "Miss Tredwell is home." She quit the next day.

One time, a man entered the mansion and encountered a woman in a period costume who told him that the home was closed to the public that day. When he came back the next day, he discovered that no one works at the house in a period costume, although they have period costumes on display. Still another time, a woman in a period costume told some noisy schoolchildren to be quiet. When they came back the next day, they also discovered that no one in a period costume worked at the museum.

The tearoom appears to be one of Miss Getrude's favorite places. Giggles and sighs, as well as moving teacups, have been reported. A ghostly woman in nineteenth-century dress was spotted in the room before she disappeared. Fresh flowers have been smelled, though none are in the mansion. She likes to play the piano in the middle of the night. People feel her nearby as the temperature drops.

I will let Executive Director Margaret Halsey Gardiner of the Merchant House Museum have the final word. Though she still has not made up her mind concerning whether the museum is haunted, she expounded to Vera

The five Tredwell sisters haunt separately, not in tandem, at the Merchant House Museum. Built in 1832, this red brick and white marble row house offers a glimpse of life in Manhattan between the War of 1812 and the Civil War.

Hale in a *Newsday* story, "Climbing the stairs to the bedroom floor and above to our offices, about three-quarters of the way up, I would get a chill up my spine, such that I stopped a lot of the times. I told whoever was there that I was their friend, I come in peace. The chills stopped maybe because now Gertrude trusts me to take care of the house and I'm safe," Gardiner said laughing.

GREENWICH VILLAGE

Aaron Burr, the Eternal Romeo

Aaron Burr is New York City's most amorous ghost. He also sometimes hangs out at D'Agostino Residence Hall (110 West Third Street) of New York University, where once upon a time he had his private stables. The area marks the site of one of early New York's most famous estates, Richmond Hill, where Vice President John Adams lived. He rented it from his friend,

Aaron Burr. The young ladies in the residence claim that he still pulls up in a horse and carriage in an effort to take them on a romantic rendezvous. A series of restaurants in the former stables on the site, before they were torn down to make way for the dormitory, reported his ghostly dining presence. His nineteenth century–style clothing attracted people's attention.

Aaron Burr was a randy dandy in his old age. He married the widowed Mrs. Jumel, who divorced him on his deathbed a few years later; he was guilty of adultery even at his advanced age of eighty! You can't keep a romantic ghost down.

What makes haunting by Aaron Burr so strange is that he is buried at the Princeton Cemetery. His arch nemesis Alexander Hamilton has a shorter commute from Trinity Church.

Samuel Clemens, the Ghost in Spite of Himself

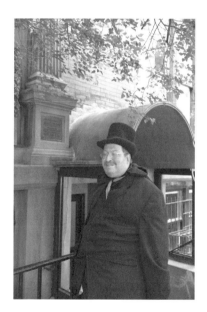

Dr. Phil calls on Samuel Clemens, better known as Mark Twain, a ghost in denial, at 14 West Tenth Street. When Clemens lived in this home at the beginning of the twentieth century, he was a literary lion much in demand as a public speaker.

One iconoclast who did not believe in the supernatural was Samuel Clemens, better known as Mark Twain, the author of *Huckleberry Finn*. He and his wife lived at the 1830 brownstone at 14 West Tenth Street. Samuel Clemens said that he heard no spirits. He mocked the ideas of ghosts in a story called "A Ghost Story" that appeared in 1903 in which a ghost haunted his own fake corpse. Despite his resolute determination to remain a nonbeliever, Samuel Clemens did describe an unusual experience he had in the brownstone. One time he saw some wood move in a chimney room. He grabbed a pistol and fired at the moving wood. Although blood was later found nearby on the stairs, and in other places in the house, no intruder was ever found.

Jan Bryant Bartell, in *Spindrift: Spray from a Psychic Sea* (1974), claimed that this was the most haunted dwelling in

Manhattan. According to the actress turned psychic turned author, Clemens was among the twenty-two spirits she believed haunted the building when she lived there with her mother in the 1930s. One of the sleep-in servants claimed to be awakened by someone touching her cheeks early in the morning, always about the same time. Some of her girlhood friends claimed to have felt presences of various kinds inside her home, which they would mistake for her initially.

Jan explained that the spirit of Clemens presented itself to her, and after telling her that his name was Clemens, he said that he was there on unfinished business. Other residents before and after her have also claimed to have seen Clemens supposedly hiding under the stairwell or visiting the billiard room.

One day, her cleaning lady reported seeing a cat go by. Jan said that she had no cat, leading her to conclude that she was visited by a ghost cat.

Although attorney Joel Steinberg lived in the house in 1987, when he was convicted of beating his six-year-old adopted daughter Jessica to death, there have surprisingly been no reports of her haunting the place.

Marcel Duchamp Still Celebrates New Year

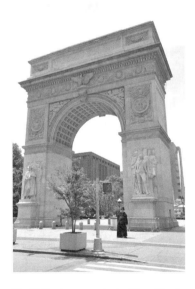

Washington Square Arch has its share of ghosts. On New Year's Eve 1916, Marcel Duchamp, a French artist, and several American artistic friends, forced open the door to the stairs. They climbed the 110 steps to the top of the arch to declare Greenwich Village to be the independent Republic of New Bohemia. John Puroy Mitchell, the mayor, called the police to end the demonstration. Ever since, the sound of a party can be heard on New Year's Eve, and champagne bottles have been found on this site on New Year's Day.

Dr. Phil tries to crash the New Year's Eve party of Marcel Duchamp, the French Dadaist and surrealist artist, at Washington Square Arch.

Fala Still Seeking His Master Franklin Roosevelt

Franklin Delano Roosevelt and his wife Eleanor had a menagerie of dogs that were shipped off to the president's home in Hyde Park, New York, because they were either not housebroken or they would bite people. His German shepherd, Major, had been exiled after biting one too many guests—ripping the pants of the British prime minister, Winston Churchill.

Fala, a gift from his favorite cousin, Margaret Suckley, proved to be the perfect political animal. He shook people's hands instead of taking a bite out of them or doing his business in inappropriate places. Roosevelt loved Fala so much that he tried as much as possible as part of his routine to feed his dog personally every day. Fala as Roosevelt's constant companion drove the Secret Service crazy. The agents worried that the terrier's presence drew too much attention to the president. Fala slept in Roosevelt's room at night.

When Roosevelt ran for president in 1944, some people claimed that he sent a naval destroyer to pick up Fala. Roosevelt used him to make fun of his political enemies. The president declared, "These Republican leaders are not content with attacks on me, on my wife or on my sons. No, not content with that. They now include my little dog Fala."

Fala roams Washington Square Park in search of the thirty-second president of the United States. He had been the dog of Franklin but not really Eleanor Roosevelt. She declared that the dog just barely tolerated her but adored his master. Fala knew Washington Square Park well, when Eleanor lived at 29 Washington Square West from 1942 to 1949. This had been intended to be the urban digs for FDR because it was wheelchair accessible. Incidentally in those rather simple days, Eleanor Roosevelt commuted between New York City and Washington, D.C., without a Secret Service escort. She did carry a gun concealed in her purse at the request of the Secret Service for protection.

Sometimes Fala would accompany his master on his train rides to Grand Central from the White House. The sculptor Neil Estern immortalized him in bronze at the Franklin Delano Roosevelt Memorial. When FDR died, Fala was heartbroken. At the country home in Hyde Park, he always stationed himself in order to view which door Franklin might come in or out. Fala was ultimately buried at his master's feet.

Who knows who you will encounter—Poe, Fala or a Leni-Lenape warrior—in Washington Square Park? Fifteen to twenty thousand bodies lie buried under the former pauper burial ground. Many of them are in search of missing body parts because of the damage inflicted by the militia when it was the Washington Square Parade Ground.

Ghost Central:
The Most Haunted Place in America

Due to the yellow fever epidemic of 1793, the city purchased the ninety lots representing two-thirds of the land that now makes up Washington Square for use as a potter's field. It had been a burial ground for a synagogue, an African Methodist church and for Revolutionary War and War of 1812 veterans. Native Americans had been buried there as well. Twenty thousand bodies were supposed to be buried anywhere from eight to thirteen feet below the surface of the park, but the gravediggers did not always dig that far down.

On February 27, 1826, the cemetery officially became the Washington Military Parade Ground, named after George Washington to celebrate the fiftieth anniversary of the signing of the Declaration of Independence. Additional land was purchased to expand the facility to its present size. Military parade grounds were public spaces within the city where voluntary militia companies trained. However, the Washington Military Parade Ground proved to be impractical to be used as parade ground, as the heavy artillery sometime fell through the graves. The bodies were supposed to be buried twenty feet below the ground, but during the epidemics, the bodies were buried only a few feet into the ground. Shortly thereafter it was gentrified, and the square was turned into a park by 1828, described by Henry James as the "ideal of quiet and genteel retirement." The militia moved up to Madison Square to continue the parade activities.

But beware! Ever since, ghostly spirits have been looking for living human beings to raid in order to replace skeletal parts that were crushed by the artillery pieces. Occasionally, Edgar Allan Poe strolls nearby.

The Gothic Tower of New York University Once Hosted the Greatest Ghost Geniuses in the Nation

The Gothic Tower (today the site of the New York University Silver Center, or the College of Arts and Science) located at 100 Washington Square East was the first building of New York University. Designed by Town, Davis & Dakin and built in 1837, this Gothic Revival structure was torn down in 1894. NYU employed some notable adjunct professors: Walt Whitman to teach poetry; Samuel F.B. Morse and Winslow Homer to teach art; Samuel Colt to teach physics; and Theodore Draper to teach chemistry and who improved the camera to take human portraits. Apparently some of the renowned scholars found it hard to depart the site of their research. Until the building was torn down in 1894, some of the students claimed that they could hear the dots and dashes of the Morse telegraph because Morse had done some of his research on the telegraph on the top floor of the building. When he perfected the telegraph, he tapped out, "Hello, Universe!" Some of the English majors also used to claim that they could hear Walt Whitman reciting some of his poetry.

Edgar Allan Poe lectured on the art of poetry and recited poetry at the Gothic Tower, New York University's first building, now replaced by Sylvan Hall.

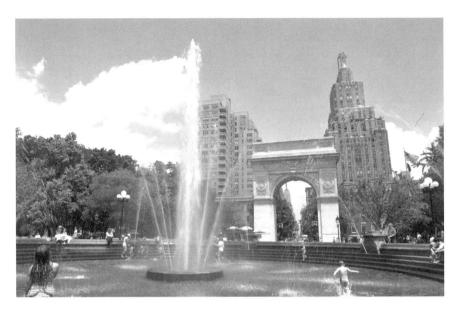

If you listen carefully at the fountain inside Washington Square Park, you may hear Woody Guthrie and other folk singers.

Woody Guthrie Hums Hanukah Songs

Woody Guthrie was a nomad who always returned to New York City. He busked songs with Leadbelly in Harlem. He wrote "This Land Is Your Land" because he thought Irving Berlin's "God Bless America" was too weak. Guthrie also wrote "Roll on, Mighty Columbia" to promote a dam project for Uncle Sam.

If you listen carefully, you may hear Woody Guthrie, folk singer and writer, playing his guitar in Washington Square Park as he did along with Rambling Jack Elliot in the 1950s. Although not Jewish himself, he likes to play Hanukkah songs that he composed when he married a Jewish woman. Since the end of World War II, folk singers have gathered around the Washington Square Park fountain to sing and strum hootenannies on late Sunday afternoons.

Hanging Ground Shows its Ghostly Side

The Hanging Ground in the northwest portion of Washington Square North is the most haunted part of the park. Washington Square Park West at Fourth

On a dark and stormy night, you may see a body swinging from one of the old trees in the park, used during a time when they used to hang them up high in New York State. The expression "up the river" originated at the beginning of the nineteenth century. Criminals convicted at trial in city hall (which doubled as a courthouse) would be sent two miles up the Hudson River to New York State's only prison in Greenwich Village. While some served a grim sentence, others awaited to be executed in future Washington Square Park.

and MacDougal Streets was used as a hanging ground during the American Revolution, and corpses were then dumped into the ground. Afterward, this area was used by the sheriff of New York County to hang criminals. For cheap entertainment, you could catch a hanging on a Saturday afternoon. The New York State Prison was located on Christopher Street, then known as Skinner Road, where the condemned would be housed. We get the expression "Up the River" not in reference to Sing Sing but to this prison, from when the accused would be tried at city hall two miles southward, and then the convicted and condemned would be transported by boat up the Hudson River to go to the prison.

Not all of those hanged were guilty. As result, their spirits have been occasionally spotted. For example, on July 8, 1819, the last known public hanging took place. A young black woman, Rose Butler, was hanged for setting fire to a house in which she worked. She never confessed to the crime because, in all likelihood, the fire was accidental. On stormy nights, people claim that they can see bodies swinging in the air.

One of the sheriffs that used to hang 'em high was Mordecai Manuel Noah, a playwright and editor of the *New York Sun*, where he employed Poe to assist him. On April 13, 1844, the *New York Sun*, the biggest penny daily, printed Poe's imaginary report:

ASTOUNDED BY NEWS OF EXPRESS, VIA NORFOLK. THE ATLANTIC CROSSED IN THREE DAYS…ARRIVAL….NEAR CHARLESTON S.C.—AFTER PASSAGE OF SEVENTY-FIVE HOURS, ETC.

Henry James Inspires Ghostly Thoughts

Henry James, whose grandmother lived at 18 Washington Square North, brilliantly depicted a nostalgic view of the house in his 1881 novel, *Washington Square*. The building has been demolished, but the remaining homes west from No. 19 on are so similar that you'll get an idea of what it was like in James's day. The building and Washington Square Park in disguise star in *The Turn of the Screw*, a subtle ghost story set in Victorian England. A governess has been hired to care for two orphans, a boy and a girl. They are a happy household until the governess begins to sense what may be ghosts. She then learns that the house has a terrible, covert heritage that might be affecting or even taking hold of the children.

John LaFarge No Longer Haunts

The artist, well known for his stained-glass windows, was the resident ghost at the studio building at 51 West Tenth Street. James Boorman Johnston commissioned Richard Morris Hunt in 1857 to create the modern building for artists in America. Hunt housed his own studio in the building, the first architectural school in America. Johnston's son, John Taylor, became the first president of the Metropolitan Museum of America, originally founded just a few blocks away. Frederick Church and Winslow Homer called this building their home when it was the center of much artistic activity in America.

John LaFarge was born in Brooklyn in 1835. He created the twelve stained-glass windows of the nearby Judson Memorial Church in 1892 at 55 Washington Square South at Thompson Street. He has made his ghostly presence known in a unique fashion. During the winter, he would create graceful portraits of people on the icy windows. In 1956, the building at 51 West Tenth Street was torn down to make way for an apartment house, and his ghostly activities stopped.

John LaFarge Haunts Occasionally

John Lafarge may haunt the Episcopal Church of the Ascension at 12 West Eleventh Street, built in 1840. People working inside the church have the feeling that he does not like the huge mural he painted (*The Ascension*) to be moved. When efforts are made to move it, accidents happen to prevent this from taking place. President John Tyler married the very wealthy Julia Gardiner at this church just before the Civil War—they eloped away from the pubic eye. The widowed president had a few daughters older than his second wife. He still holds the record of any president having the most children: seventeen.

Emma Lazarus Welcomes Ghosts New and Old

Emma Lazarus prided herself a descendant among the early Jewish settlers of New York City. During the Russian pogroms of the 1880s, she began to write about Jewish issues and became known for defending the oppressed and organizing relief efforts for refugees at Ward's Island (today's Roosevelt Island). She became a Zionist who advocated the return and restoration of the Jews to the Holy Land.

Now and then you can hear Emma Lazarus reciting "The New Colossus" at 18 West Tenth Street.

Emma Lazarus is best known for "The New Colossus," a sonnet written in 1883, solicited by William Maxwell Evarts as a donation to an auction, conducted by the Art Loan Fund Exhibition in Aid of the Bartholdi Pedestal Fund for the Statue of Liberty to raise funds to build the pedestal in collaboration with Joseph Pulitzer's fundraising efforts. The sonnet fetched $1,500, the equivalent of $150,000 today, but it was forgotten. Twenty years later, a woman found a used book that contained a collection of essays, poems and art that included the sonnet by Lazarus. She campaigned to have its final lines engraved on a bronze plaque in the pedestal of the Statue of Liberty in 1912.

Whenever the debate over immigration becomes intense, people can hear Lazarus reciting her poem at 14 West Tenth Street. Dying at the young age of thirty-eight from tuberculosis, she still has unfinished business.

Minetta Stream, the Ghost Stream of Washington Square Park

Washington Square Park has a genuine ghost stream, as do other parts of Manhattan. Minetta Lane is named after the Minetta stream that made Washington Square Park a swamp. The nine-and-three-quarters-acre park was created because of a stream, the Minetta ("The Little One") Water, which the Dutch called Betavaar's Kill ("Grandfather's Little Creek"). It began with tributaries that flowed south and joined near Eighth Street and Sixth Avenue to flow on through the present park. There the stream veered southwest, continuing along the parts of today's Minetta Lane, Minetta Street and Downing Street. It emptied into a salt marsh near the foot of Canal Street. The change in the direction of the trout steam made the future park a swamp. The early Dutch settlers fished in this little stream and hunted the water fowl that flourished in the marsh.

Though no longer visible, the water still flows in lesser volume in its own channel. It still flows underground despite the streets, pavements and apartments that have covered it up. Several buildings have pumps to keep the steam out. *As Time Goes By*, a book about New York City volunteer fire companies, shows where these streams still flow despite the construction that has taken place. Egbert Viele's 1874 map of Manhattan is still used today by civil engineers because it shows the original shoreline and underground waterways. The apartment building at 2 Fifth Avenue even has a fountain in the lobby whose waters are still drawn from Manetta Creek below. Manetta

Creek was named after a primeval monster of Leni-Lenape legend, one that was banished to the sea to make way for Native American civilization.

Greenwich Village was once an actual Indian village named Sapohannikan or "Tobacco Field," which stood on the banks of Manetta Creek (spelled "Minetta" by the Dutch, thus today's Minetta Lane). Occasional Leni-Lenape whoops can be heard.

Molly of NYU's Brittany Dormitory Makes it Onto the Internet

The former Brittany Hotel at 55 East Tenth Street is now the Brittany Residence Hall of NYU. It was built in 1929. Guests included the Grateful Dead's Jerry Garcia and actor Al Pacino.

People report hearing footsteps in their rooms and feeling unknown presences. My nephew Gabe Schoenberg told me on June 12, 2008, that a neighbor of his in the NYU dorm at 35 Fifth Avenue had moved from Brittany. She lived on the fifteenth floor but found the ghostly noise coming from the sixteenth floor too much to bear.

As further proof of the ghost's existence, consider the following e-mail I received from another Brittany Hall resident:

> My name is Justin Dayhoff, a resident assistant at NYU's Brittany Residence Hall. We are currently looking into hosting a program this month involving a discussion of careers in paranormal research and investigation as well as inviting guests to investigate strange occurrences that frequent this residence hall from our ghost "Molly." I'm unaware if you know the story of "Molly," but it is understood that when this used to be a hotel, due to construction the door at the top of the elevator shafts was unlocked and a little girl made her way in and fell to her death. It is believed that many of the strange things that happen here are caused by her.

Edgar Allan Poe, America's Most Popular Ghost

Edgar Allan Poe is considered by many people to be the father of supernatural story, the detective story and the science fiction story. Ironically, he may be America's most popular ghost even though he did not believe in ghosts himself.

Poe was born in Boston, Massachusetts. Both of his parents were actors. Upon the death of his mother, he was taken in by John and Frances Alan.

Dr. Phil calls on Edgar Allan Poe at 85 West Third Street. Ironically, he no longer haunts there.

Once he became estranged from his stepfather, he always wrote Edgar A. Poe. He did spend five years abroad with his stepfather in England and Scotland. While abroad, he may have learned some Hebrew.

By far, Edgar Allan Poe is America's most popular ghost. He has been reported haunting simultaneously more than any other ghost in America: Baltimore, Maryland; Richmond, Virginia; Philadelphia, Pennsylvania; Boston, Massachusetts; and, of course, New York. The reason why he appears in so many locations in New York City is because he could not pay the rent in a timely fashion and consequently had to move around a lot. Poe preferred to maintain a middle-class lifestyle even though he did not have the income to sustain it.

Poe stayed at a four-story house at 85 West Third Street in Greenwich Village for eight months in 1845 and 1846. The move may have been prompted by the hope that the country air would be good for the tubercular Mrs. Poe. Mrs. Shew acted as his wife's nurse and later would become an object of Poe's romantic attentions after he was widowed. Number 85 West Third Street is where Poe wrote "The Facts in the Case of M. Valdemar," and it is one of many places where he worked on his great poetic masterpiece "The Raven." He also edited the *Broadway Journal* magazine here, which contained some poetic contributions from Walt Whitman. The house was demolished in 2002 after a strenuous court battle.

Passersby used to report seeing Poe's phantom at the third-floor, east-side window. However, he has been absent ever since the house was demolished in 2002 by NYU to build a dormitory for its law students, despite NYU incorporating part of the old façade into the new building. NYU's version is only three-stories high instead of four. The old façade had actually been constructed after Poe had left the building, while seven hundred interior

bricks were donated to the Poe Museum in Baltimore. Of Edgar Allan Poe's ghostly spirit, "Quoth the Raven, 'Nevermore.'"

Poe in life had a more pleasant association with the University of the City of New York, as the college was then known. Between 1844 and 1848, Edgar Allan Poe lectured or recited at the Gothic Tower for the New York Historical Society and the New York Society Library. Before the building was torn down, sometimes people would claim to feel his ghostly presence in the main auditorium.

Poe was asked by the Philomathean and Eucleian Societies of New York University to read a poem at commencement exercises on July 1, 1845, at the Gothic Tower. He was unable to write a new poem and pleaded indisposition. The eccentric poet Dr. Thomas Holey Chivers, who first met him about then, found him in bed but not sick.

Edgar Allan Poe's First Recitation of "The Raven" in Public

Edgar Allan Poe recited "The Raven" in public for the first time in 1845 at the literary salon of Charlotte Lynch. He had borrowed fifty dollars from one of her guests, fellow poet William Cullen Bryant.

In 1845, Poe entered into the society of literary people for the first time. He met Miss Anne Charlotte Lynch, whose literary soirees in Greenwich Village were famous. She later married Professor Vicenza Botta of New York University and continued to be a leading hostess throughout her life. At 116 Waverly Place on July 19, 1845, Poe read "The Raven" at her request for the first time in public. Poe could be charming and even possessed some charisma. The charm and brilliance of his conversation are recorded—and his reticence, too. He also borrowed fifty dollars from fellow poet William Cullen Bryant, the editor of the *New York Evening Post*.

This was a far cry from 1837, when Poe was treated for a head cold at the Northern Dispensary at 165 Waverly Place. The building is popularly known in Manhattan, with two sides on one street

and one side on two streets. On one side Grove merges with Christopher Street, a connection known as Stonewall place. The intersection once called Factory and Sixth Streets is today the corner of Waverly Place and Waverly Place. No, Edgar does not haunt there.

Fire Patrol Officer Schwartz Haunts His Comrades

Opposite the former Poe House is Fire Patrol Station No. 2 at 84 West Third Street. It was founded by the New York Board of Fire Underwriters in 1839 to alert volunteer fire companies of fires, until replaced by professional fire companies in 1865, and then to protect property after 1865. This station was one of three remaining until it and its sister stations were closed in 2006, the 100th anniversary at this location; it was no longer deemed cost effective.

The reported suicide of a fire patrolman sometime in the 1930s is believed to be the cause of the haunting. The patrolman, identified by a psychic only as "Schwartz," came home to find his wife in bed with a man who was not him. Despondent over the extramarital affair, he hanged himself from a sturdy rafter on the fourth floor of Station No. 2. Another psychic claimed that the phantom remained in the building desperately searching for something it had left behind.

Since then, his ghostly presence has been heard, felt and seen on that top floor by several patrol officers. They have reported encounters in which the apparition, dressed in a firefighting uniform from the 1930s, appears and disappears suddenly, moves objects and even taps patrolmen on the hands as they walk down the building's narrow, winding metal staircase. Now that the fire station is closed, is ghostly activity still taking place? The building is now owned by NYU, which may tear it down despite community opposition.

Triangle Shirt Waist Factory Fire Haunts

On March 25, 1911, 146 women died in a horrific fire at the Triangle Shirtwaist Factory on the eighth, ninth and tenth floors of what was then called the Asch Building at 23–39 Washington Place. Although the building was designed to be fireproof, the factory's sweatshop operators in their greedy pursuit of profit had managed to undo all the safety precautions. The floors were strewn with stray garments and raw materials that were quite combustible. It did not help that the workers freely smoked despite

constant admonitions not to do so. The doors were locked to keep out union organizers, prevent unauthorized rest breaks and to stop theft. Some of the workers smoked inside the building despite a few ineffectual crackdowns by the official New York State factory inspectors. The sweatshop working conditions resulted in unsafe overcrowding. On March 25, 1911, this dangerous combination became deadly when a spark ignited a fire just before quitting time at 4:45 p.m.

When management was told of the fire, they simply took the elevators down and left without telling their employees. They had no organized evacuation plan or thought to alert the workers.

Luck determined survival. Only half the workers had shown up on Saturday following a long and bitter strike. All 70 workers on the tenth floor survived. They were helped by NYU law students and professors, who observed the commotion. However, 145 workers from the ninth floor perished through smoke inhalation or jumping from the building. The workers jammed against the factory doors, which opened inward; the harder they piled on the exit doors, the tighter they became—deathtraps. The elevator operators shuttled workers down until it was too hot. Then women jumped on top during their last run, which saved their lives but made the elevators inoperable. The fire escapes proved too rickety to be used. Skyscraper fires required new technology, which the New York City Fire Department lacked. Their firefighting and rescue equipment did not reach beyond the seventh floor. People bounded off the safety nets or through them.

Although the New York Fire Department put out the flames in less than twenty minutes, 146 workers had died. Heroically, the firemen had the fire under control within eighteen minutes and extinguished it in another ten minutes. This was the third-greatest loss of life in New York City after the sinking of the *General Slocum* on June 15, 1904, and 9/11.

From December 4 to December 27, 1911, a trial was held in which over one hundred witnesses were called; Max Harris and Isaac Blank were charged with causing the death of Margaret Schwartz. The prosecution charged that the doors were locked; the defense swore that the doors were not. On December 27, Judge Crain read to the jury the text of Article 6, Section 80, of New York's Labor Law: "All doors leading in or to any such factory shall be so constructed as to open outwardly where practicable, and shall not be locked, bolted, or fastened during working hours." Crain told the jury that in order to return a verdict of guilty they must first find that the door was locked during the fire and that the defendants knew or should have known that it was locked. The judge also told the jury that they must

The third biggest loss of human life in New York City occurred on March 25, 1911, in which 146 sweatshop workers died inside the Asch Building, now NYU's Brown Building.

find beyond a reasonable doubt that the locked door caused the death of Margaret Schwartz. After two hours, the jury found that the factory owners were not guilty. When the prosecution decided to charge the owners with the death of another worker, the judge ruled that it was double jeopardy. The owners of the Asch building settled twenty-three civil suits on the average of seventy-five dollars within three years of the fire. Although the New York City Buildings Inspection Department was faulted for failure to inspect factories, the politicians rallied to protect the bureaucrats.

The unions made a big issue of the fire by pointing out that no one could count on either management or the state to look after the workers; they had to depend on themselves. A special New York State legislative commission between 1911 and 1914 investigated the matter. One of the members that helped pass laws to improve safety conditions and went on to greater fame was Democrat Al Smith, who would become governor of New York State and the first Catholic to run for president. The chief investigator was Frances Perkins, who would become the first female federal cabinet member, secretary of labor, under President Franklin Roosevelt. Thirty-six laws were enacted at the commission's recommendation.

On the anniversary of the fire, March 25, the New York Fire Department brings over its ladder trucks. They go up to the eighth floor, which was the height they could then reach one hundred years ago. Then they go up to the ninth floor, as if making an effort to save women trapped on the tenth floor.

There doesn't appear to be any spirits from the Shirtwaist Factory fire, only occasionally vague impressions of residual energy in the atmosphere that convey a muted sense of desperate desire to escape that day. Students report sometimes feeling a sense of urgency to escape, or stuffiness, as if they need to get outdoors quickly to take a deep breath. On the night of the anniversary of the fire, some people smell the smoke still lingering in the air.

Is It Mayor Jimmy Walker or the Shadow that Haunts this Brownstone?

Jimmy Walker, the son of Irish immigrants, was born in New York City on June 19, 1881. After graduating from St. Francis Xavier College and New York University Law School, Walker worked as a songwriter. He only had one success, "Will You Love Me in December as You Do in May" (1905).

As a Tammany Hall politico, he was mayor of New York City from 1926 to 1932 until forced to resign because of a scandal. His consolation was that he could now marry his mistress, Betty Compton. Fiorello LaGuardia, his political opponent, graciously appointed him a labor arbitrator when he fell on hard times.

Sometimes Jimmy pays a visit to George M. Cohan at Times Square, and they dance the Irish jig together.

Betty Compton lived at 12 Gay Street in a two-story house near the Northern Dispensary in the 1920s. A ghost in top hat and tails has been reported from time to time walking up and down the street, although it has not been identified as Jimmy Walker. Dogs have been reported to wag their tails at the ghostly visitor's presence or signal that they smell it.

Lynda Lee Macker, in her book *Ghostly Gotham: New York City's Haunted History*, suggests that it is a fictional character brought to life. Walter Gibson was such a vivid writer for *The Shadow* radio show that he brought Lamont Cranston from the world of fiction into the supernatural world. Gibson often fantasized that he was haunted by the characters he wrote for radio in the 1940s when he lived in the apartment.

WEST VILLAGE

Aaron Burr in his horse-drawn carriage likes to pick up college co-eds at 110 West Third Street, the location of his former stables, now a dormitory for NYU law students.

Theodosia Burr Snatches Earrings Where Her Father also Haunts

Another favorite location for the father-daughter couple of Aaron and Theodosia Burr is the One if by Land, Two if by Sea Restaurant at 17 Barrow Street, Burr's former carriage house, in the West Village. Many visitors and restaurant employees have observed flying dishes and chairs being pulled out from under patrons, supposedly by Aaron. His daughter, Theodosia, also haunts the former carriage house—female patrons at the bar have had their earrings popped off by an envious Theodosia. I had someone on my Ghost of the City tours lose her earrings near Trinity Church.

Henrietta Chumley, Drunken Phantom

Chumley's Bar at 86 Bedford Street is visited by its former hard-drinking owner, Henrietta Chumley, who comes to drink a Manhattan. In life, she would drink until she passed out. One day, she did not wake up. Now and then, she breaks some glasses. The former owner also makes her presence known by messing with the restaurant's jukebox. When a videogame was installed, it had so many problems that it was taken out. Her husband, Lee Chumley, who founded the speakeasy in 1928, is also known to make an appearance.

Thomas Paine, the Phantom Rejected by Three Countries

It is interesting that some spirits roam at the location where an original building was destroyed, while others cease to haunt a place once it is destroyed. Thomas Paine's restless spirit haunts Marie's Tavern at 69 Grove

Street even though the original building burned down in 1839. Perhaps he is still present, because it is one of the few places that still remembers him along with some of the original brickwork. The present building is named for Paine's *Crisis Papers*, which began with the famous line, "These are the times that try men's souls." However, Tom Paine lived up to his name, becoming a royal pain in England, America and France.

Back in England, Paine was a pamphleteer who criticized the British government. Benjamin Franklin gave him a recommendation letter that he used when he arrived in America. Benjamin Franklin once said to Paine, "Where liberty is, there is my country," to which Paine replied, "Where liberty is not, there is mine." His immortal words in *Common Sense* aroused the troops to fight for America's freedom.

Once the American Revolution was won, Paine moved on to the French Revolution, and he had a falling out with the French revolutionaries. Radical as he was in favor of a republic, he aroused ire for refusing to approve the death penalty for the deposed French monarch Louis XVI. Only the fact that he still retained his American citizenship prevented him from being hanged. However, he was scarcely grateful to those that came to his rescue.

Paine even had a gift for turning his own friends against him. He became the least likable of the Founding Fathers and had no supporters left in his own lifetime or after death to champion his ideas. Although he was deist, most people considered him to be an atheist because of his attacks on organized religion in his book, *The Age of Reason*. Little wonder that he died alone in 1809 at 69 Grove Street. When people argue at the tavern today, sometimes they find a voice from nowhere joining their arguments.

Dylan Thomas, a Good Ghost Host

The White Horse Tavern at 567 Hudson Street at West Eleventh Street boasts Dylan Thomas, the Welsh poet, as a resident ghost. In November 1953, he claimed to have drunk a record eighteen shots of whiskey in one night, though the bartender counted nine. Whatever the number, it proved to be fatal. St. Vincent's Hospital could not save him from himself.

Since then, Dylan Thomas has reappeared as a friendly ghost who occasionally provides free drinks at his favorite corner table. Sometimes, a porter hears him down in the cellar. An empty beer glass or whiskey shot glass on his favorite table, where no one has been seen drinking, is evidence of his spectral activity.

Titanic *Ghosts in Search of a Secure Landing*

The Riverview Hotel at 113 Jane Street was once the American Seaman's Friend Society, built in 1907 to offer accommodations to captains and first officers of the luxury ships of the day.

The frightened survivors of the *Titanic* were brought over from the *Carpathia*, the ship that had rescued them, but it may also have contained the doomed souls that had not made it. Since then, elevators have arrived unsummoned, cold spots have been experienced in different locations of the hotel and moans and groans have been heard in certain rooms.

Ye Waverly Inn Phantom May Be a Firebug

The employees of Ye Waverly Inn at 16 Bank Street claim to have seen ghostly figures. They blame the ghosts for starting fires. Built in 1844, the Waverly Inn is currently packed with celebrities, not spirits. As recently as 1997, however, the inn boasted a spectral guest list. A fire that devastated the building in 1977 left the restaurant's smoking room, room 16, unscathed. Hostess Maria Ennes was quoted at the time attributing the room's salvation to its resident spirit, saying: "It's where the ghost likes to be." Apparently the top hat– and waistcoat-wearing phantom was fond of spooking waitresses by moving andirons in the fireplace and sometimes dampening the blazes. The ghost was also accused of switching the keys on the computer for meatloaf and fried chicken. In 1999, Jane Poirer and her partner Patrick Hynes bought the restaurant. She says that there is a resident ghost dressed in nineteenth-century garb often mistaken for her by the employees. Working late at night, she found a relief to have ghosts present.

CHELSEA

Did Clement Clarke Moore Get the Fame He Wanted or Deserved?

Clement Clarke Moore is the resident ghost at 487 Hudson Street, where he served as the church's first pastor. He was originally buried near the church before being reinterred uptown at Trinity Church Cemetery and Mausoleum in Upper Manhattan. His groans and moans have increased

over the years. In his day, Moore was well known as the professor of Greek literature at Columbia University, a compiler of a two-volume Hebrew dictionary and as the professor at General Theological Seminary. In his lifetime, he accepted unchallenged credit for an anonymous publication of "A Visit from St. Nicholas" (more commonly known today as "Twas the Night Before Christmas") in 1823. It is the most famous opening line of any poem in the English language. Today, he is known for that. And some people challenge that he did not write the poem! Wouldn't you be unable to rest in your grave, too?

Sid Vicious Lived Up to His Name

Be particularly careful when you ride the elevator at the Chelsea Hotel at 222 West Twenty-third Street; the ghost of Sid Vicious is reported to linger in the elevator. Rocker Sid Vicious, lead singer of the Sex Pistols, allegedly stabbed girlfriend Nancy Spungen to death in the bathroom of room 100 in 1978. He died of a heroin overdose.

The Chelsea Hotel originally opened in 1884 as one of New York City's first cooperative apartments. It was converted into a hotel in 1905. J.P. Morgan, Andrew Carnegie, Dylan Thomas, Eugene O'Neill, Samuel Clemens and Thomas Wolfe have all been seen in spirit form. Its Star Lounge has been reported to attract ghosts that like to drink their troubles away.

Edith Wharton Came From a Family of Doers

Edith Jones (1862–1937) was born in a house that still stands at 14 West Twenty-third Street. Her family then lived at the large house at 7 Washington Square North. Her father, John Johnston, was a successful importer/exporter and a founder of NYU. Her brother became the first president of Metropolitan Museum of Art. She moved here from Europe at the age of twenty after her father died in 1881. In *The Age of Innocence*, she wrote about events set in the 1870s, when Washington Square would have been the very center of New York's high society. Wharton was from a prominent family and lived in a world where people "always lived well, dressed expensively, and did little else," as she described in *The House of Mirth*. Her books dealt with the shifting of old-family quiet wealth to the excesses of the more cosmopolitan Gilded Age. She was the first woman to win the Pulitzer Prize. Wharton was a good friend of Henry

James, and they would visit each other frequently. She wrote her own haunting tales, which have been published as *The Ghost Stories of Edith Wharton*.

FLATIRON MADISON SQUARE

Stanford White in Search of a Place to Haunt

Stanford White was the Hugh Hefner of his day except that he was far more flamboyant and outgoing than the twentieth-century business executive of sex. He loved being in the public eye and reading about his sexual exploits and sensual rompings; while on Long Island his wife turned a blind eye. In 1880, he joined Charles Follen McKim and William Rutherford Mead in founding McKim, Mead and White, the foremost architectural team as the nineteenth became the twentieth century.

Stanford White usually paid for his fun quite generously, though he was not above using knock-out drugs to help him achieve his seductions, as in the case of Evelyn Nesbit. After a period of time, they parted on amicable terms. After resisting the importunings of Henry K. Thaw for two years, she agreed to marry him. He was a playboy himself who loved to beat his girlfriends and his romantic rivals with a whip. He whipped Nesbit on their honeymoon to find out about her affair with White. Thaw then obsessed that somebody had gotten to his wife's virginity first. On June 25, 1906, Thaw killed White at the Second Madison Square Garden that White had designed.

Thaw and White shared something in common. Just as White had Delmonico's Restaurant cater his love nest, Thaw had his food provided by Delmonico's for the nine months that he was in jail until he was tried for his crime. After two jury trials, Prosecutor William Travers Jerome, the grandfather of Winston Churchill, failed to make his case for first-degree murder, and Thaw was found not guilty of the killing of Stanford White by reason of insanity. Delphin Delmas had been the first defense lawyer to invoke the plea of temporary insanity since Francis Scott Key's son Philip Baron Key had been killed by Congressman and future Civil War general Daniel Sickles for messing with his wife.

Stanford White now wanders Madison Square Park in search of the Madison Square Garden and other buildings now demolished that he designed. This facility, designed by him, was moved to Penn Station and replaced by the New York Life Building.

STUYVESANT SQUARE

Elizabeth Blackwell, Feminist Pioneer Extraordinaire

Many people have reported hearing unexplained footsteps, noises and voices throughout the Beth Israel Medical Center on Sixteenth Street. On occasion, Elizabeth Blackwell, America's first female doctor, is reported as present. In life she had worked at the nearby women's infirmary on Stuyvesant Square. Elizabeth Blackwell had graduated at the head of her class from Geneva College in Upstate New York in 1849. The faculty had put her admission to the students for a vote! She became the first female doctor to practice in England. Dr. Elizabeth Blackwell along with her sister established a college to train female doctors in America, and Florence Nightingale engineered the same in England. She was also America's first gynecologist. You can always tell it is her because she is wearing pants, which was considered scandalous for a woman in the nineteenth century. Perhaps Dr. Blackwell haunts because she dared not only to do a man's job well but to do it better than anybody else.

GRAMERCY PARK

Chester Alan Arthur, the Ultimate Political Survivor

Sometimes late in the evening passersby see Chester A. Arthur, a man with mutton chop whiskers, conferring with Edwin Booth's statue in Gramercy Park or taking a walk from his mansion. They may be joined by the spirit of Samuel Ruggles, the creator of Union and Gramercy Squares.

Even though Arthur was a spoilsman, a beneficiary of the various Republican political machines of the time, he did have his idealistic side. Before the Civil War, he was successful in winning a judgment of $500 from Third Avenue Trolley Car Company. This would be equivalent of winning $50,000 today. Not only did his black client get compensated for being denied transportation in the segregated system, Arthur managed to have its segregation practices ended in the resulting judgment.

Arthur was a product of the political system of his day. He worked his way up to the biggest patronage position of all time, collector of the port of New York. Paid a fee as a percentage of the goods, the holder of the office in a

good year could make more than the president of the United States. More than one thousand people were employed in the office. In 1878, Rutherford B. Hayes decided to fire Arthur for corruption but could not prove the case.

In the 1880 Republican Convention, the supporters of Ulysses S. Grant's third term were thrown a sop when Arthur was offered the position of vice president. It was proffered as a consolation prize for being fired from the New York port collector's office. Against the advice of New York State Republican party leader Roscoe Conkling, he accepted.

Charles J. Guiteau, disgruntled by failed efforts to secure a federal patronage post, shot James Garfield on July 2, 1881, at a railroad station in Washington, D.C. Ironically, the president was killed by medical treatments of his day. The efforts of the doctors to find the bullet spread infection. Not everyone yet believed in the germ theory or the need to wash their hands. On September 19, 1881, he finally succumbed.

Upon the death of James Garfield, a New York state judge administered to Chester A. Arthur the presidential oath. He took the oath again in Washington, D.C. This time it was given by federal judge just to make sure that there would be no legal problems that a nonfederal official had administered the oath.

In turn, Arthur successfully hid the secret that he was dying from Bright's disease so that he would not be a lame duck president. Arthur is remembered chiefly for signing into law in 1883 the Pendleton Act that created the federal civil service examination system. When the widowed president was asked about his love life, he replied, "It is none of the public's damned business."

Edwin Booth, Haunted by His Brother's Evil Deed

The Players, a two-story brownstone at 16 Gramercy Park South, was the home of actor Edwin Booth at the time of his death. Decades earlier, his brother, John Wilkes Booth, had assassinated Abraham Lincoln. At the time of the assassination, he issued a statement in which he declared that he shared the sadness of the occasion but would stand by to help his brother. Ironically, he had in his possession a letter from the president thanking him for rescuing his son, Robert, who had fallen from the railroad platform in Newark, New Jersey. Every few years, he would stage a "final" farewell season. Edwin Booth, considered one of the greatest American actors of the nineteenth century, had been overshadowed by his younger brother's act as assassination. His fame could never equal his brother's infamy.

Edwin Booth hired Stanford White to redesign the building. He founded the club in 1888 to elevate the social status of actors. They were not considered quite respectable in conservative society in those days. Booth hoped actors and non-actors would mix together in the hopes of creating a cultural atmosphere for fellow actors, who were considered coarse bohemians by much of society.

On June 7, 1893, a big thunderstorm blacked out the entire building. Booth was taking his final bow because he was dying on the top floor of the building. His daughter's prayers were answered that he should die in the light. His spirit departed his body during a lightning flash. That very night the balcony in Ford's Theatre where Lincoln had been assassinated collapsed also. Occasionally, during lightning storms, people claim to see him again. A statue of him playing a part in *Hamlet* can be seen in Gramercy Square Park. Sometimes the ghostly spirit of Chester A. Arthur can be seen chatting with the statue.

John Carradine, the Original Mad Scientist

The building at 34 Gramercy Park East dating from the 1880s is among the earliest cooperative apartment buildings in New York City. John Carradine played mad doctor roles in movies such as *Arsenic and Old Lace* and Woody Allen's *Everything You Always Wanted to Know about Sex* (*But Were Afraid to Ask)*; he also played Hamlet and Macbeth in his own productions of the Shakespeare plays.

Samuel Clemens Plays Billards

Another haunt at the Players is Samuel Clemens. He had such a passion for billiards that his picture hangs in the billiards room. Some of the members claimed to have played the game with his departed spirit.

The One Invention that Thomas Alva Edison Could Not Claim

There is no ghost at 24 Gramercy Park South. The inventor Thomas Alva Edison was only thirty-four years old, but he was already world famous and very wealthy when he rented an apartment at this site with his wife, Mary,

and their young daughter, Marion, in the winter of 1881. He lived here for the next two years. He had just invented the phonograph and would shortly invent the light bulb and the direct current power system.

Popular imagination ran rampant that he was trying to research an invention to communicate with ghosts and dead people. After all, he had invented the phonograph. In 1883, he moved permanently to New Jersey, and no more was heard of his efforts to communicate with the dead. The original house was demolished in 1908 and replaced by the modern building. Thanks to his invention of the phonograph and the movie projector, we do have a way of reliving the past and capturing ghosts on film.

John Garfield, Cursed by a Play?

Is it a mere coincidence that John Garfield started and ended his acting career with *Golden Boy*? His real name was Julius Garfinkle before Hollywood changed it. Clifford Odets wrote the original Broadway production with John Garfield in mind, but Garfield received a supporting role when it opened on November 4, 1937, at the Belasco Theatre. It proved the biggest success of Clifford Odets's career as a playwright. In the 1939 movie version, it made William Holden a star. When World War II broke out, Garfield attempted to enlist but was turned down because of a bad heart. He and Bette Davis were the driving force behind the Hollywood Canteen, which entertained servicemen. Famous for playing rebellious characters, he continued to be outspoken after World War II and lived at an apartment at 3 Gramercy Park West. John Garfield was only thirty-nine years old when he died in the home of a friend, Iris Whitney, on May 23, 1952. He had been starring in the Broadway revival of *Golden Boy* at the time of his death. Occasionally, people report hearing the actor practicing his lines for the play.

Margaret Hamilton, Not the Wicked Witch in Real Life

Margaret Hamilton played the Wicked Witch of the West in *The Wizard of Oz* (1939). As a former elementary school teacher, she crusaded for improving education. Wouldn't you like to have visited her apartment at 34 Gramercy Park East for trick or treating during Halloween?

O. Henry Still Writes Away

Peter's Tavern bar at 129 East Eighteenth Street contends with McSorley's Old Ale House and the Bridge Café as the oldest continuous bar in New York City. William Sydney Porter, pen name O. Henry, frequented Peter's in the early 1900s. He wrote many stories, including "The Gift of the Magi," to beat a deadline or to pay a last-minute bill. Occasionally, his ghost has been spotted in a booth, writing away. He would get pickled to write some of his stories. If you get pickled, you might see him, too.

Washington Irving Met Charles Dickens

No ghostly activity is reported at 46 East Twenty-first Street, where Charles Dickens used to stay at his nephew's mansion, long since torn down. He edited or revised many of his ghost stories for publication there. In 1842, the English author visited Washington Irving at his mansion. He gave Irving credit for preserving English ghost stories. A year later, he wrote *A Christmas Carol*. I would like to have been the fly on the wall when Charles Dickens visited there in 1842.

There is a plaque at 120 East Seventeenth Street or 49 Irving Place (same building with two addresses) that claims that Irving lived there. Washington Irving might have visited his nephew Edgar Irving, who bought the residence there in 1851, but he did not live there, contrary to the bronze plaque put up in 1934. This seems to have been the product of wishful thinking by nonrelatives who bought the place.

The eight-story brick, limestone and terra-cotta Washington Irving High School at 40 Irving Place, designed by architect C.B.J. Snyder, opened in 1913 as a specialized high school for girls, the first such in the city that emphasized such "womanly arts" as sewing and secretarial work. The interior public spaces of Washington Irving High School are some of most impressive of the public schools in Manhattan. For example, they contain scenes from the *Early History of Manhattan* (1916–21) by Barry Faulkner that tie in very nicely with the books written by Washington Irving. Outside is a giant bust of Washington Irving by Frederick Beer (1935). Today, it is a coed high school. The exterior was used for the TV sit-com *Head of the Class*.

Benjamin Sonnenberg,
the Second-Largest Haunted Private Mansion in New York

This six-story, thirty-seven-room, eighteen-thousand-square-foot mansion at 19 Gramercy Square South was originally built in 1845 for William Samuel Johnson, a Whig politician. It was then redesigned by architect Stanford White in 1887 for Stuyvesant Fish and his wife Mary "Mamie" Fish. Since so many of their friends of the "400 Club" were on the board as directors of his Illinois Central Railroad, it was nicknamed the "Society Railroad." His wife was able to outdo her great social rivals in a most economical fashion. She completed her formal dinner parties in fifty minutes instead of having them take several hours. Some successive owners complained that they could still hear the orchestra playing music.

Benjamin Sonnenberg, the great public relations guru, continued this tradition when he lived here from 1945 to 1978. He was an immigrant from Russia who rose from poverty to great success. Sonnenberg could get your face on the cover of *Time* or *Fortune* magazines. He spent lavishly on entertainment and decorating his home, but the food he served could be as simple as roast beef on bread and champagne.

Richard Tyler, a fashion designer, likes to think that Sonnenberg welcomed him into the house. In a fit of insomnia, he was wandering around his newly acquired home when he turned on an unplugged radio that played big-band music. His visiting sisters later told him that they also heard the music.

Fittingly, this house is the center of action in the novel *Time and Again* by Jack Finney—it is where Simon Morley lives for a period of time.

The Stuyvesant Artist Apparitions

This five-story, twenty-apartment, red brick building at 142 East Eighteenth Street was one of the earliest apartment buildings in New York City. Richard Morris Hunt designed it for Rutherford Stuyvesant. If you were a Stuyvesant, you were a real estate developer, as you transformed farmland into middle- and upper-class housing. The widow of General George A. Custer, Henry Wadsworth Longfellow, Oliver Wendell Holmes, Edwin Booth, Calvert Vaux, Isadora Duncan and Queen Juliana of the Netherlands shared their digs with three ghosts in the building. The *New York Times* of September 22, 1957, reported an anonymous, elegant couple present. Another spirit, a French artist, engaged in automatic writing to solicit support for the arts.

The hauntings ceased in 1957 when the building was torn down to make way for the much larger Gramercy Green at the newly dubbed address 130 East Eighteenth Street.

The Samuel Tilden Home, the Largest Haunted Private Mansion in New York

Samuel Tilden's former home at 15 Gramercy Park South is now a private club for the arts, the National Arts Club. The largest Victorian mansion in New York City was the residence of Samuel Tilden. He had prosecuted Boss Tweed for corruption. He had become governor of New York State. He lost the presidency through a crooked deal. Upon his death, he left so much money that Lenox and Astor Libraries combined to form the free New York Public Library. Among its Victorian Gothic decorations are medallions portraying Goethe, Dante, Milton and Benjamin Franklin.

Samuel J. Tilden purchased this townhouse in 1863; he later purchased the house next door at no. 14. In 1881, he asked designer Calvert Vaux of Central Park fame to combine the two structures with a unified Revival façade in 1883–84. Tilden, a political reformer who made some enemies, was concerned with his personal safety. Vaux's remodeling also included a secret escape tunnel to East Nineteenth Street.

Following the 2000 election, ghostly voices were heard in the mansion: "Those God-damn Republicans stole the election again!" Tilden was the Democratic governor of New York and the Democratic presidential candidate who in 1876 received more popular votes than Rutherford B. Hayes. The electoral votes were disputed. Zachariah Chandler, the chairman of the Republican National Committee and publisher of the *New York Times*, stole the election. The disputed electoral votes came from two southern states that were still occupied by federal troops and states out west that the Democrats claimed. A commission voted on party lines to award the electoral votes to the Republican candidate. By sacrificing black Republicans to Jim Crow in the South, the chairman made a deal with the southern Democrats not to protest the result. Thus, Samuel Tilden was deprived of becoming the president of the United States through the machinations of Zachariah Chandler.

Although Rutherford B. Hayes swore that he made no such deal, he followed through by withdrawing federal troops and nominating a southerner to be a cabinet officer. It was he who fired Chester A. Arthur as the collector of the port of New York.

Oscar Wilde, Humorist Ghost Writer

Oscar Wilde lodged at 47 Irving Place in 1883 while his unsuccessful play *Vera* was in rehearsal at the nearby Union Square Theatre at the other end of the block facing Union Square. His play *The Importance of Being Ernest* is still widely performed. People still read *The Picture of Dorian Gray*. In "The Canterville Ghost," we meet the cowardly ghost Sir Simon, undone by the modern American cleaning techniques of Hiram B. Otis, the American minister to England. In the end, it is the poor ghost that is terrorized before he achieves his redemption.

MIDTOWN EAST

The Grand Central Train to Hell

Even phantoms ask the information specialists for directions beneath the clock! An information clerk at Grand Central once escorted a young lady to a nearby residence only to discover that she was a ghost.

A century ago, the station manager was waiting for the arrival of the 12:05 a.m. from Westchester. An awaiting passenger declared that the train from hell was coming to pick him up at midnight. He ran to the station manager for assistance. The station manager declared that there was no midnight train as they waited for the 12:05 a.m. from Westchester. Come two minutes before midnight, a train whistle blew. The passenger screamed, "The train for hell has come for me!" The station manager indeed heard a train whistle at midnight as he grabbed hold of the passenger, whom he felt was about to commit suicide. The passenger disappeared from his grasp. He heard a train whistle, and other passengers came forward to investigate the empty space. All that the station manager saw was the hat of the departed passenger in his hand. As a mournful whistle could be heard in the background, one of passersby asked, "What was it?" The station manager declared, "I do believe that was the express train to hell!" Since this is Grand Central, the train should have stopped, because there are no railroad tracks south of Grand Central.

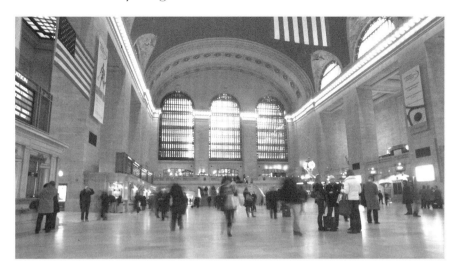

Grand Central has ghosts commuting among the living. In 1947, more than sixty-five million people—the equivalent of 40 percent of the U.S. population—traveled through Grand Central Terminal. It is still the busiest railroad station in the country despite the decline of rail passenger transportation.

Ghostly Commuters of Grand Central

Since Grand Central is the busiest railroad station in America, it is natural that some of its commuters are ghosts still going about their business out of habit or because they do not know they are dead. Some ghosts commute to find better places to haunt. A few go away on vacation. Others seek warmer or colder climes as the seasons change. Some of the information specialists at the booths have seen their questioners literally evaporate in front of them once they answered all their questions.

Abraham Lincoln Death Train

Abraham Lincoln's death train has been reported inside New York City's limits, even inside Grand Central Station, though it did not exist at the time. Before there was a Grand Central, there were rail tracks on Fourth or Park Avenue. In April 1865, Abraham Lincoln's body began a funeral journey from Washington, D.C., via New York City to his hometown of Springfield, Illinois. Ever since then, in various parts of the nation, the train has been spotted toward dusk on the day it journeyed along for so long. Some people

The midnight train to hell makes no stop but picks up passengers doomed to be punished for eternity. According to legend, the Lincoln death train comes from the south, even though no tracks exist any more. Legend claims that clocks slow down in its wake.

see a steam train moving slowly away, and with it goes the darkness, the chill and the clouds that obscure the moon. Others claim that they can see inside the train a crew of skeletons. Halfway back in the train is Lincoln's coffin, surrounded by a crew of blue-coated skeletons. Or the train is simply a blur. It has been reported seen between Twenty-first Street and all the way up to Albany over the original path of the old New York Central Railroad. Wherever the train passes, the clocks become six minutes late. In *Spooky New York*, S.E. Schlosser retells the arrival of the Lincoln death train inside Grand Central, which was built after his death.

TIMES SQUARE

Martin Beck the Protesting Ghost

In his day, producer Martin Beck was the man to see, because he discovered talent such as Harry Houdini in 1899, ran the Orpheum Circuit and even opened the ultimate vaudeville theatre, the Palace at 302 West Forty-fifth Street, with Sarah Bernhardt as the opening act. No wonder a theatre was named in his honor in 1924.

In 2003, the theatre was named for Al Hirschfield. Beck seems to be one unhappy ghost, eternally displeased that the one place that bore his name now bears the name of another. As the shows come to their final run, jeers appear to be heard from nowhere.

David Belasco, the Casting Couch Ghost

Catching a glimpse of the phantom of David Belasco is regarded as a good omen. He haunts the theatre named after him, the Belasco Theatre at 111 West Forty-fourth Street. He is one of New York's most popular ghosts. A multitasker, he manifests himself in several different ways: visual, auditory, kinesthetic, touching and olfactory, in different parts of one of the oldest theatres in Times Square. He still cannot make a final stage call. David Belasco died in May 1931, within a year of his retirement from the theatre.

Having worked in the circus, Belasco pioneered "montage," a form of lighting and the use of the elevator stage. To this day, the stage curtain moves up halfway, stops and once again lowers, as if Belasco was present and bowing

David Belasco could never retire from the theatre he named after himself. He has been reported in several locations, from on-stage to sitting with the audience to his famous casting couch.

in person in his own unique style. The elevator still rumbles going to the top of the theatre, where he lived, although its cables were severed, the shaft sealed and the motor disconnected. Cigar smoke has been reported in different parts of the building. Those who knew him in life could identify his favorite cigars. Doors on the stage have been known to open unexpectedly or at the same time. His casting coach in his office still appears to be quite active.

David Belasco's spirit has a nickname, "the Monk," because of his signature clothing that made him look like a Catholic monk. This reflected his earlier education in the Catholic schools even though he was Jewish.

"The Monk" likes to make his appearance on opening night from his favorite box seat in life as if evaluating the performances. Better yet, actors rehearsing their scenes see his specter. He has been known to chat with audience members, congratulate the directors and encourages the actors. Upon occasion, some of the actresses claimed that an elderly priest has pinched their rear ends! He has been spotted on dark stairways and deserted hallways.

Finally, even animals sense his presence. A caretaker's dog would howl every day at the same time, 4:00 p.m., when it was customary for David Belasco to make his rounds in the theatre.

Louis Borsaline, the Ghost You Do Not Want to See

Of the 103 haunts at the Palace Theatre at 1564 Broadway, you do not want to see the specter of Louis Borsaline. Seeing his spook is considered bad luck because it means you will soon die. Louis Borsaline, one of the "Four Casting Pearls" act, perished after he fell and broke his neck while balancing on the tightrope in the 1950s. The more fortunate just hear his screams.

George M. Cohan, the great songwriter, dancer and producer, has been known to dance an Irish jig with Mayor Jimmy Walker.

George M. Cohan Still Gives His Regards to Broadway

The George M. Cohan statue at Times Square at Broadway and Forty-sixth Street is reported to dance after midnight on July 4. In 1959, at the behest of composer Oscar Hammerstein II, an eight-foot bronze statue of Cohan was dedicated in Times Square at Broadway and Forty-sixth in Manhattan. George Michael Cohan claimed that he was born the son of Irish immigrants on the Fourth of July 1878. He was an entertainer, playwright, composer, lyricist, actor, singer, dancer, director and producer.

As the father of American musical comedy, Cohan pioneered the musical theatre libretto, invented the "book musical"—becoming the first showman to bridge the gaps between drama and music, operetta and extravaganza—and used dance not merely as razzle-dazzle but to advance the plot.

Cohan had his first big Broadway hit in 1904 with the show *Little Johnny Jones*, which introduced his tunes "Give My Regards to Broadway" and "The Yankee Doodle Boy." As one of the leading Tin Pan Alley songwriters, he published 1,500 original songs such as "You're a Grand Old Flag," "Mary's a Grand Old Name" and the very popular war song, "Over There." Cohan is that rarity: a happy ghost! Sometimes, he is joined in his singing by composer-politician Jimmy Walker.

Elizabeth Baron, a psychic reader, claimed to have heard his voice or felt his energy in several of the theatres in which he performed.

Clyde Fitch's Final Bow

Born in Elmira, New York, Clyde Fitch wrote over sixty plays for the Broadway stage. He was the first American playwright to publish his own plays. In 1896, he wrote the lyrics to the popular song "Love Makes the World Go 'Round." In 1900, the play *Captain Jinks of the Horse Marines*

made a star of Ethel Barrymore. At one point, he had five plays running on Broadway, and he was the first American playwright to be successful in England.

December 21, 1909, was the opening night of *The City* at the Lyric Theatre at 213 West Forty-second Street. It was the last play by the prolific Fitch (*Beau Brummell*, *Barbara Frietchie* and *Captain Jinks*), who had died the previous summer in Europe. As the cast of *The City* was taking their final curtain calls, women in the audience screamed and fainted as the unmistakable figure of the late author emerged from the wings, strode to center stage, took a deep bow...and vanished right before everyone's startled eyes.

Bob Fosse, Still Smoking Away

Bob Fosse has been known to make a guest appearance in the theatre named for the renowned Broadway composer Richard Rodgers at 226 West Forty-sixth Street. When people smell tobacco smoke, they know that the cigarette chain-smoker Bob Fosse is present. In 1955, Bob Fosse won a Tony for *Damn Yankees* as outstanding musical, which ran for 1,019 performances. He also married its star, Gwen Verdon and choreographed *The Pajama Game* and *Sweet Charity*. Sometimes one of his hats appears unexpectedly because he wore them to hide his baldness.

Judy Garland, the Best the Palace Has to Offer

Judy Garland, one of the greatest female movie stars and singers of all time, is sensed near the rear orchestra door built for her in the Palace Theatre at 1564 Broadway and Forty-seventh Street. Another witness described a spectral encounter at the stage door in the alley of the theatre. On October 6, 1995, Elizabeth Baron visited the theatre at the request of some of her clients, many of the cast and crew members of the Disney production currently playing there, *Beauty and the Beast*. She claimed in the course of her readings with her clients that the spirit of Judy Garland had tried to come through to communicate messages for her daughter Liza Minnelli.

Above, left: When you smell smoke or see an unusual hat at the Richard Rodgers Theatre, you know that Bob Fosse, the dancer and choreographer, is present.

Above, right: Judy Garland has been channeled among the 103 ghosts at the Palace, the premier vaudeville venue.

Ghost Light Wards off Bad Luck

A tradition in the theatre is to leave behind a naked light bulb on a tall pole when the crew strikes the set. This light is known as a "ghost light." It stays on all night to avoid bad luck.

Leslie Howard as Hamlet

The battle of the Hamlets raged on Broadway in the fall of 1936. John Gielgud opened first as the "Melancholy Dane" at the long-gone Empire Theatre in October and triumphed. Leslie Howard played the same part at the Imperial Theatre at 249 West Forty-fifth Street in November 1936 and came in a poor second. Howard's last Broadway play had been *The Petrified Forest*. When reviewing Howard's Hamlet, critic Robert Benchley wrote in the *New Yorker* that it was "the petrified Hamlet." Gielgud's production ran for 132 performances, Howard's only 39. It was Leslie Howard, a British

World War I veteran, who insisted that Humphrey Bogart get the role of Duke Mantee in the film version of *The Petrified Forest* (1936), the character that Bogart played in the stage production. The Imperial Theatre was the home of one of Broadway's longest-running musicals, *Les Miserables*.

At the Belasco Theatre, stagehands working on the 1995 production of *Hamlet*, starring Ralph Fiennes, reported that they heard "strange sounds." Others heard a hazy voice hum, croon and wail. One witness reported seeing a ghostly being with white, tousled hair. Other crew members wondered if there were interlopers in the theatre of impresario David Belasco because the draperies moved on their own.

The Palace Theatre, the Most Haunted Theatre in America

In 1913, Martin Beck, the Broadway producer, built the Palace Theatre at 1564 Broadway. It was considered to be the height of vaudeville in its heyday. Anytime you "played the Palace," you had hit the big time. On an October 6, 1995 visit to the theatre, Elizabeth Baron, a psychic reader, claimed that 103 ghosts haunted the Palace. They are still waiting for their big break. These include a white-gowned cellist playing in the pit and a young girl looking down from the balcony. Judy Garland got the greatest break while Louis Borsaline got the worst break. Read their stories elsewhere.

Patrick Stewart as Macbeth

Patrick Stewart is not yet a guest nor does he play one. He does star in productions that have ghosts such as *Macbeth* or *A Christmas Carol*. Who would ever suspect that this bald-headed actor was trained in Shakespearean theatre in England and that he would become a heartbreaker in the *Star Trek* television series. It is traditionally considered bad luck by actors to mention William Shakespeare's play *Macbeth* by its real title. Actors generally call this haunting drama "the Scottish play." It has its share of ghostly activities, fatalities and superstitions. In March 2008, Patrick Stewart brought an English production of the stage play to the Lyceum Theatre at 149 West Forty-fifth Street. He played Macbeth as a mid-level gangbanger who wants the top job in this production conceived and directed by Rupert Goold.

There was even a riot over the proper accent involving *Macbeth* at the Astor Place Opera House at 98 East Eighth Street. Today a Kmart occupies

the site. One of the worst disasters in the history of the theatre took place May 10, 1849. Anti-British feelings were running so high among New York's Irish at the height of the potato famine that they found an outlet in the rivalry between two of the most famous stars of the day, American Edwin Forrest and "the eminent tragedian," Englishman William Charles Macready, who were announced to play Macbeth on the same night. A professional feud, fueled by jingoism, erupted into a scene of violence not seen before or since in the annals of the theatre. Edwin Forrest hissed against William Macready for the slight he received in London; Macready had hissed Forrest in Edinburgh, Scotland. The upper classes championed the British accent, the lower classes the American accent. Their partisans escalated from words to fisticuffs in the streets, which soon became a riot. When the smoke cleared, twenty men lay dead and the theatre was destroyed. Since the rioters were punished, apparently no ghosts were produced. The theatre itself never recovered from the associations and was razed in the 1860s.

Ed Sullivan Theatre Specters Get Their Fifteen Minutes of Fame

The Ed Sullivan Theatre at 1697–1699 Broadway between Fifty-third and Fifty-fourth Streets has long been rumored to be haunted. Today, *The Late Show with David Letterman* is filmed live from the theatre-studio. It debuted on CBS on August 30, 1995. Internet websites stream a clip of a team of four investigators from New York City Paranormal Investigations into the theatre. David Letterman interviewed Rupert before and after the investigation on his show on October 10, 2005. The investigators on air detected several unexplained sudden temperature drops and unusual electromagnetic field (EMF) readings. A dark shadow passing before the camera and an orb moving erratically appeared on the video footage.

Olive Thomas, the Fashionable Flapper Ghost

Olive Thomas poisoned herself accidentally, if you believe her husband, Jack Pickford, Mary Pickford's brother. At the beginning of the Roaring Twenties, the Ziegfeld showgirl thought that she made a perfect match by marrying into silent film acting dynasty. He played young, clean-cut types on the screen but boozed, gambled and did drugs off screen. This

Olive Thomas still performs at the New Amsterdam Theatre. The costume she wears may change upon occasion.

made for a stormy marriage, and they separated.

A few months later, they reconciled and decided to have a second honeymoon in Paris. During the middle of night at the Ritz Hotel, she awoke without turning on the light. She took her husband's medication, treatment for syphilis, instead of her own. Just as her dreams of stardom were coming true, she died from the deadly medicine. Flo Ziegfeld paid for her lavish funeral, though he did not attend the service or any other funeral service. Although buried at Woodlawn Cemetery in the Bronx, she has haunted the New Amsterdam Theatre at 214 West Forty-second Street.

When her friends and colleagues were in the theatre on stage and back stage or sat in the audience, Olive Thomas would join in the performance or watch along with the crowd. Although her clothing might change, Olive Thomas, always flapper fashionable, can be identified by the blue glass bottle that contained the deadly pills that changed her into a ghost. When her friends no longer performed or attended the theatre, the workmen began to notice the presence of a melancholy girl early in the morning on stage. When they approached, she would disappear. Olive Thomas has been reported in other parts of the theatre.

Midtown West

Algonquin Hotel Apparitions, the Original Gossip Crowd before the Internet

Many guests at the Algonquin Hotel at 59 West Forty-fourth Street have claimed to spot members of "the Round Table," a group of writers that met daily at the Algonquin for lunch after World War I. Members of the

Ghostly Neighborhoods and Their Inhabitants

Algonquin Round Table. Not shown in the painting is Harpo Marx, who was an Algonquin Round Table regular.

Once upon a time, this round table at the Algonquin Hotel hosted Dorothy Parker, poet; Robert Benchley, newspaper columnist and film actor; Robert Sherwood, playwright; Harpo Marx, comedian; Alexander Woollcott, critic; Harold Ross, editor; George S. Kaufman, playwright; Heywood Broun, newspaper columnist; Marc Connelly; and Edna Ferber, author.

Round Table (who called themselves the "Vicious Circle") included Dorothy Parker, poet; Robert Benchley, newspaper columnist and film actor; Robert Sherwood, playwright; Harpo Marx, comedian; Alexander Woollcott, critic; Harold Ross, editor; George S. Kaufman, playwright; Heywood Broun, newspaper columnist; Marc Connelly, playwright; and Edna Ferber, novelist. The Sedgewick Hotel in the movie *Ghostbusters* (1984) was modeled after the Algonquin Hotel.

In *Harpo Speaks*, Harpo Marx recounts a story in which he thought of how to commit the perfect murder during a mystery game they would play during a weekend getaway. However, he was discovered to be the culprit in a few seconds. Instead of saying the words "You're dead" to the victim, Harpo had written them on toilet paper. Everything was perfect, except that he wrote, "You're ded." Only he in the entire group could make such a mistake.

Empire State Building Suicide Ghosts Still Happening

Although legend claims that one person died for each of the Empire State Building's 102 stories, only five construction workers actually died in accidents. The building at 350 Fifth Avenue was built in the record time of eighteen months. It became the tallest building in New York City and the United States in 1931, beating out the Chrysler Building and 40 Wall Street. In 1933, King Kong climbed this edifice thanks to the magic of the cinema.

Because of the Depression and initial lack of pubic transportation, so much space went unrented that it received the nickname of the "Empty State Building." Of course, empty buildings have a way of attracting ghosts.

When the building opened for business, it replaced Brooklyn Bridge as suicide central. Despite precautions, once in a while people still jump off from the eighty-sixth-floor observation tower. One man jumped down an elevator shaft; every once in a while he repeats this epic feat in ghostly form. Various sightings have been reported of suicide victims who have jumped from the Empire State Building's observatory. Incidentally, a penny thrown from top of the building will land on the upper parts of the building.

Harvard Club Hosts RAF Ghosts

During World War II, Oswald Risen ran into two Royal Air Force pilots in Times Square who asked for directions. Since he was awaiting induction

into the military himself, he decided to show them to his club, the Harvard Club at 35 West Forty-fourth Street, to find out what he would be facing. He had a most entertaining lunch with the pilots, who always seemed to be looking at their watches. As the hour approached midnight, the pilots thanked their host, casually mentioned that they had been killed flying over Berlin the night before and disappeared.

New York Public Library Has No Ghosts

One of the first cases in the movie *Ghostbusters* takes place in the New York Public Library at Forty-second Street and Fifth Avenue. However, the interior shots were filmed in the Los Angels Public Library. The firm of John Merven Carrère and Thomas Hastings designed in 1902 the Beaux Arts structure, the largest marble building up to that time in the United States. Although it houses one of the largest research collections of the world, I can personally tell you that it does not offer much in the way of supernatural research. The building replaced an earlier structure, a giant water reservoir. Since the library opened to the public upon completion of the building in 1911, no supernatural occurrences have been reported throughout its more than one hundred miles of bookshelves.

S.L. "Roxy" Rothafel Rocks!

John D. Rockefeller Jr. decided as the economy went into a downspin in 1929 that he would have a tough market in renting space. He decided that a series of buildings sharing common amenities and architectural design would be the way to go. He decided that "Roxy" Rothafel would be the ideal guy to open up the largest indoor theatre in the nation (even today), Radio City Music Hall at 1260 Sixth Avenue and Fiftieth Street, as one of the crown jewels of Rockefeller Center.

Rothafel was a showman of the 1920s silent film era who pioneered synchronizing orchestral music to the silent movies and having multiple projectors to effect seamless reel changes. Rothafel also opened Radio City Music Hall in 1932, which featured the precision dance troupe the Roxyettes, later renamed the Rockettes. Radio City Music Hall became famous for having live shows between the movies, but people forgot that this was the custom from the 1920s to the 1940s in America.

On opening nights, Radio City Music Hall's builder, Samuel Lionel "Roxy" Rothafel, accompanied by a glamorous female companion, has been seen at 1260 Sixth Avenue in Rockefeller Center.

CLINTON

June Havoc Gets a Ghost Psychoanalyzed

One day June Havoc, the sister of Gypsy Rose Lee, complained to her friend Helen Hayes that she had a tough time going to sleep because she kept hearing noises about three or four in the morning that kept her up. The plumbers had found the pipes in her Victorian mansion at 428 West Forty-fourth Street to be in good working order.

Hayes recommended that she use the celebrity ghost hunter of the day; this being the 1960s, it was Hans Holzer. He called in his associate Sybil Leek, an English witch, astrologer, psychic and occult author, to do the channeling.

They discovered that Lucy Ryan was causing the problem. Back in 1782, Ryan had suffered a tragic end. Instead of meeting her lover, a soldier, at a rendezvous in the area, she was raped by a gang of soldiers. Too weak from her wounds to call out or to move, she died from hunger. Lucy complained of being hungry all the time, so she received the nickname of "Hungry Lucy."

After one more séance, Holzer and Leak were able to convince the ghost to depart—or to use their own jargon, the spirit was released.

For her part, June Havoc remained a skeptic, although she did say, "I am still the stoutest nonbeliever…Something had to be doing this, but I didn't see anything."

Old Moor, the Ghost Who Was Not

Legend claims that "Old Moor," a ghost of unknown origin, haunted the home of either Governor George or his nephew, Governor DeWitt Clinton, toward the end of their lives, and reports of ghostly manifestations continued well into the twentieth century at 420 West Forty-sixth Street. DeWitt Clinton had a ghostly experience at his mansion because he had unknowingly built his stables over a former potter's field. Clinton is famous as the builder of the

Erie Canal that helped to make New York City the country's leading port in the nineteenth century.

Christopher Gray's "Streetscapes: Readers' Questions" column of September 6, 1992, in the *New York Times* reveals that the history of the building's haunting is a complete myth. Neither George Clinton, the first and third governor of New York State, nor his nephew DeWitt Clinton, the sixth and eighth governor of New York State, ever lived in the area. DeWitt Clinton died ten years earlier than the time during which his presence was claimed. He died in 1828 in Upstate New York and was reinterred in Greenwood Cemetery in Brooklyn. His uncle had died sixteen years earlier in Washington, D.C., the first vice president to die in office, and was reinterred in his hometown of Kingston, New York. The building was built in 1871, and additions were made in 1919. Ruth Faison Shaw, an artist who lived in the rear of the building in the 1940s and 1950s, was the first to tell ghost stories involving the building. She claimed that "Old Moor," either a black slave executed for running away or a pirate executed by the British, was the first ghost. She claimed that the building had been constructed over a potter's field. As other people moved in, they came up with other stories of ghostly hauntings.

George Raft, Loyal to the Old Neighborhood

John Strau in the *New York Times* article "Turf of Gangs and Gangsters," reported that George Raft does not forget the old neighborhood, even if it is now called Clinton instead of Hell's Kitchen, as it was when he was growing up. Now and then, he can be seen as a ghost getting a drink at the Landmark Tavern at the corner of 626 Eleventh Avenue and Forty-sixth Street. He was a boyhood friend of the gangster Owney Madden and narrowly avoided a life of crime. Through Madden, he became friends with several other gangsters later, including Meyer Lansky. Because of these connections, he became very popular playing cinematic gangsters in the 1930s and 1940s.

The Landmark Tavern has been in business since 1868. George Raft might have met some ghosts there before he became one himself. For example, now and then a Confederate veteran of the Civil War has been known to make an appearance after dying in a knife fight.

UPPER WEST SIDE

Edward Severin Clark, the Ghost with the Toupee

The Dakota at 1 West Seventy-second Street has become ghost central of the Upper West Side in the twentieth century. For one of the earliest apartments for the very rich, Edward Severin Clark commissioned Henry Janeway Hardenbergh to design the building built between 1880 and 1884.

Clark finds it hard to leave his beloved Dakota. He pops up from time to time and shakes his toupee violently at workmen in the basement of the building when he does not approve of the work they are doing. Contrary to popular legend, he named the building the Dakota because he had fondness for the names of the western states. If he had his way, Montana Avenue or Arizona Avenue would have been some of the Upper West Side street names.

To add to the eeriness, the building was also the setting for Roman Polanski's *Rosemary's Baby* (1968), based on the novel by Ira Levin. Rosemary Woodhouse discovers a coven of witches and warlocks in the Bramford, as the building is called in the film.

James Dean in Love

In October 1951, following the advice of actor James Whitmore and his mentor Rogers Brackett, James Dean moved to New York City. He worked as a stunt tester for the game show *Beat the Clock*, as well as appearing on several CBS television series. James Dean still visits the second floor of a former rooming house at 19 West Sixty-eighth Street, where he maintained an apartment even after moving to Hollywood. His spectral visits take place because his girlfriend Barbara Glenn threw him out. People see Dean apologizing to her.

The Ghostbusters *Building, Spook Central*

The troubled apartment of Sigourney Weaver's *Ghostbusters* character is located at 55 Central Park West between Sixty-fifth and Sixty-sixth Streets. It was a rental built in 1930 that became a housing cooperative. Rudy Valee and Ginger Rogers called this art deco building on the West Side their home. Number 55

Central Park West was the first full art deco building built on the West Side. Donna Karan now lives here. In *Ghostbusters*, an insane architect named Ivo Shandor supposedly started a secret society in this building that he designed in 1920. Through the magic of Hollywood, the building was made much taller. At one point, the building was spook central and opened up to a pathway to hell during the efforts of the Ghostbusters to exorcise the building.

Boris Karloff Has a Problem with Halloween

The actor Boris Karloff tried to enjoy Halloween. Every year, he would hang a bag of candy outside his door for the children in the building to take. Because of his reputation after appearing in *Frankenstein* (1931), it remained untouched. Masterful as Lon Chaney was as Frankenstein's monster in the days of silent pictures, Karloff became unforgettable in the sound version of the role.

John Lennon Haunts

John Lennon, who was murdered outside the Dakota at 1 West Seventy-second Street in 1980, is also rumored to haunt the area around the undertaker's gate. Helene Iulo, the vice-president of the John Lennon Society, claims to have channeled his spirit on occasion. Apparently, Lennon's spirit likes to travel. Paul McCartney claimed that he saw a bird that he thought represented Lennon's spirit. John Lennon owned the commercial rights to "Happy Birthday," so if it was played on the radio or television, he was due royalties.

Rudolph Valentino, the Greatest Romeo of the Silent Movies

Like many Hollywood stars, Rudolph Valentino became an overnight success after many years of hard work. Once Valentino was processed through Ellis Island at age eighteen, he went from bussing table to taxi dancing to parts in opera to bit roles in pictures. He even played minor roles in a tour production headed by Al Jolson.

His breakout role was as a "Latin lover" in *Four Horsemen of the Apocalypse* and *The Sheik*. In the latter, he played the role as a member of a noble and

advanced civilization. When Valentino suffered an artistic slump because he didn't like the fact that movie studios decided what motion pictures he should be in, he went on strike until he was able to get creative control of his career and have salary demands realized. He was able to do very well on the road in a dance tour and found a sponsor for beauty contests he judged. Finally, the movie studios of the day had to increase his salary, from $1,250 to $7,500 a week.

Valentino's love life with Natacha Rambova was complicated. They got into trouble because he did not wait a whole year under California's divorce law of the time for his divorce from his first wife to become final. Ironically, he had sued his first wife for desertion and for having never consummated the marriage. He was slapped with bigamy charges that took some time to resolve, but then, as they say in the advertising biz, the publicity was invaluable.

Just when Valentino had it all—fame, fortune and marriage—he collapsed suddenly at the Ambassador Hotel in New York City on August 15, 1926. He was taken to the hospital, where he was operated on for appendicitis and ulcers. Unfortunately, peritonitis had set in and he died on August 23, 1926, at the age of thirty-one. He had died so suddenly and unexpectedly that he had left a legacy and inheritance for his second wife's aunt but not for her!

One hundred thousand people showed up for his funeral at the Frank Campbell Funeral Home in Manhattan. A Catholic mass was celebrated at the Roman Catholic church in Times Square and again on the West Coast. He is buried in California.

Valentino does haunt on the East Coast at the Hotel des Artistes at 1 West Sixty-seventh Street, where he had earlier spent some time. His presence is signaled by a blur in a hallway mirror and a whiff of exotic cologne. Rumors of a ghost that touches people have been circulating for years.

Mae West Got in Trouble for Taking Her Mother's Advice

Mae West took up writing her own material to perform on the stage on the advice of dear old mom. When she refused to pay protection money to a "morality" organization, they staged her arrest in 1927. With a keen eye for publicity, Mae West took advantage of the publicity the trial generated. She received a ten-day sentence and served on Roosevelt Island, where she dined every night with the warden and wife. When she got out, the rest was history.

It also helped that her old friend George Raft wanted her to be in his 1932 picture *Night after Night*, which launched her movie career.

Though a Brooklyn gal, her spirit lingers in Manhattan at 266 West End Avenue at Seventy-second Street, where she lived in the 1920s and 1930s.

UPPER EAST SIDE

Elizabeth Wolcott Gracie Takes Up Haunting

In *Ghostbusters II*, the mayor of New York mentions to one of his aides that he spent an hour in his bedroom talking with Fiorello LaGuardia, "and he's been dead for forty years." The Gracie mansion at East End Avenue and Eighty-fourth Street has a real ghost, though, in the person of Elizabeth Wolcott Gracie. Ellen Stern, author of *Gracie Mansion*, claims that New York City's official mayoral residence has a ghost. The gossip columnist Cindy Adams echoed her claim that Elizabeth Wolcott Gracie, daughter-in-law of shipping merchant Archibald Gracie, died of apoplexy there in 1819 and that "her ghost still floats through from time to time." No one knows whether Archibald Gracie designed the mansion, but we know that it was built in 1799.

It was the first home of the Museum of the City of New York from 1924 to 1936. Fiorello LaGuardia accepted Robert Moses's recommendation to make this mansion the official residence of the mayor in 1942. The Gracie family remains one of the wealthiest families in the city.

Abigail Adams Smith Is at Home to Receive Guests

Abigail Adams, the daughter of President John Adams and his wife Abigail, married Williams Stephen Smith. They built a grand mansion overlooking a twenty-three-acre estate at 421 East ResSixty-first Street on the East River. They named it Mount Vernon in honor of the estate of her father's good friend, George Washington. Eventually, the mansion burned down, and the carriage house in 1826 was transformed into an elegant hotel, the Mount Vernon Hotel. Today, it is owned by the Colonial Dames of America. Now and then, one of the docents or educational interpreters hears her footsteps. Though the size of the green space has been greatly diminished, it is still somewhat incongruous to see an early nineteenth-century building possessing such a big lawn.

Vandevroot Sisters, Still Skating in Search of their Princes

Over the years, the Vandevroot sisters, Janet and Rosetta, have shifted their ages and locations. Their father felt that they were entitled to a prince and only a prince who met his expectations and who was not after his money. Like the Tredwell sisters, they never married. Since the 1860s, they have been reported skating over the iced ponds of southeastern Central Park before gliding over the ice at Wolman Rink. Sometimes they are reported to be old; sometimes they are reported to be young. Always they are sad figures who never found their princes.

HARLEM

Harry Houdini, Restless Spirit

Harry Houdini haunts the townhouse at 278 West 113th Street in Harlem where he practiced and perfected his magic tricks. He had an extra deep bathtub installed for his water tricks. His mother spent the last twenty years of her life living with him and his wife, Wilhelmina Beatrice Rahner. There is even a photograph of the three of them together signed by the magician, "To my two sweethearts." Mom died in 1913, years before he took up his anti-séance crusade.

Sadly, in death he rests with his beloved parents and his brother at Machpelah Cemetery but not with his beloved wife, a Christian, who is buried in a New England cemetery. For a number a years after World War II, the Society of American Magicians would hold a ceremony on Halloween and break a wand over Harry Houdini's grave at Machpelah Cemetery, which is located on the Queens side of the Brooklyn-Queens border. Finally, the ceremony came to an end decades ago because of a modern fact of life stronger than magic, stronger than death, stronger than haunting and stronger than any demon from hell—liability insurance. Nobody was willing to put up the insurance to permit the ceremony to continue.

Bishop James Pike's Encounter with a Ghost

When Bishop James Pike became the dean of Cathedral of St. John the Divine at 1047 Amsterdam Avenue, he discovered a ghost inside the deanery.

Under continuous construction since 1892, the building is now the largest cathedral and fourth-largest church in the world. One of his predecessors, David Hummell Greer (1844–1919), is intent on a mission to find a valuable cross that he had lost. Pike could hear the shuffling of feet about the premises of the deanery as the ghost looked for this lost object.

World War I Haunts at the City College

The City College of New York at Broadway at 134th Street was originally founded as the Free Academy of the City of New York in 1847 by Townsend Harris. It became the first public college that charged no tuition. In 1867, it was the first college in the nation to have a student government. At one point, the college bought no books for its library for thirty years because it was cheaper than expanding the library. In 1906, the college moved to Gothic-style buildings at its present location designed by George Browne Post. Shepherd Hall was the largest building he designed.

The City College of New York at 138th Street and Convent Avenue is a hangout for ghosts from yesteryear. In the 1920s, students known to have died in the First World War were seen on campus. Legend has it that in one particular instance, a math tutor noticed that a student's clothes seemed somewhat dated for the mid-1920s and put it in his mind to inquire as to how the young man was making out financially; given it was still a wholly free college with a mostly working-class student body. Only later that night did this absent-minded professor wake up from sleep with a start, scaring his wife in the process, with the recollection that the young man died in France in 1918. Apparitions dressed in 1960s and 1970s clothes, including one ghost in particular who appears in grunge attire always "sad looking," are only seen just before or after closing hours.

WASHINGTON HEIGHTS

Eliza Jumel, the Lizzie Borden of the Ghost World

Eliza Jumel is a ghost in her own right at the Morris-Jumel Mansion at 65 Jumel Terrace. Built in 1765 as a summer home for British colonel Roger Morris and his wife, the Morris-Jumel Mansion is the oldest remaining house

in Manhattan. It served as George Washington's headquarters in September and October 1776 during the American Revolutionary War.

Eliza Jumel, former mistress of the mansion, has been seen wandering the house in a purple dress, rapping on walls and windows. Eliza and Stephen Jumel took control of the house in 1810. Their marriage was quite tumultuous, as Eliza was supposedly having an affair with Aaron Burr. In 1832, Stephen met his death as he mysteriously fell on a pitchfork. Without wasting any time, Eliza married Aaron Burr. Eliza divorced Burr three years later for still playing around at age eighty. Burr died not long after, and Eliza's mental health deteriorated because of Alzheimer's.

The hauntings began soon after her death in 1865, as Eliza was allegedly seen wandering about the property in a white dress and producing spine-tingling noises. When a psychic went to the mansion and purportedly summoned the spirit of Stephen Jumel, the spirit said that he was murdered and buried alive. In 1964, Eliza, wearing a violet dress, supposedly appeared to some schoolchildren and yelled at them to "shut up!"

GREATEST TELLERS OF GHOST STORIES

Everybody has their tastes. Here are some of my favorites.

New York City Ghost Stories (1996) by Charles J. Adams III. I used this book as the first basis of my research into the New York haunting scene.

Ghosts I Have Met and Some Others (1898) by John Kendrick Bangs. This has some witty stories of ghosts and ghost busters. His story of the water ghost is one of the most memorable.

Blithe Spirit by Noel Coward. This is a hoot on stage.

"A Ghost Story" by Samuel Clemens. Mark Twain has his own ghost haunt himself!

A Christmas Carol by Charles Dickens. The ghosts work to redeem Scrooge.

Turn of the Screw by Henry James. This suggests that such things are all in our minds, or are they?

"The Fall of the House of Usher" or "The Raven" by Edgar Allan Poe. These works suggests that we can mistakenly think that we have become ghosts or that we can be summoned by the supernatural.

Appendix 1

Spooky New York (2005) by S.E. Schlosser. This author is a magnificent storyteller of New York State ghost stories.

"The Legend of Sleepy Hollow" by Washington Irving. This truly frightens. It is one of the first battles of the brain versus brawn in which brawn actually wins.

"The Canterville Ghost" by Oscar Wilde. This work playfully mocks ghosts and ghost busting.

APPENDIX 2

MY FAVORITE CINEMATIC GHOST STORIES

I am listing them in the order they were made.

Topper (1937). This was my first introduction to the possibility that ghosts can be fun and helpful.

The Canterville Ghost (1944). Charles Laughton plays Sir Simon de Canterville, a ghost so feckless that he cannot even scare his distant eight-year-old descendant, Lady Jessica, played by Margaret O'Brien.

Abbot and Costello Meet Frankenstein (1944). This is not a bad Abbot and Costello outing as we get the Wolf Man, the Invisible Man, Dracula and Frankenstein's monster all in the same humorous epic.

The Time of Their Lives (1946). I consider this one of the best Abbot and Costello outings.

The Ghost and Mrs. Muir (1947). The strong-willed widow Lucy Muir, played by Gene Tierney, falls in love with the redoubtable ghost Captain Gregg, played by Rex Harrison.

Blackbeard's Ghost (1968). Peter Ustinov makes you believe that he is a ghost who wants to move on.

The Shining (1980). This rivals the book in presenting the supernatural.

Poltergeist (1982). Just when you think the movie comes to an end, you get another surprise.

Ghostbusters (1984). Three unemployed parapsychology professors go into business as ghost busters.

Beetlejuice (1988). This is just one bizarre haunting.

Ghostbusters II (1989). The original ghost busters are reduced to doing children's parties to get by in the continuation of their epic story.

Casper the Friendly Ghost (1995). Makes a sacrifice in remaining a phantom.

The Sixth Sense (1999). Bruce Willis actually acts in this movie as he helps a little boy cope with the supernatural.

The Blair Witch Project (1999). Makes you think you are taking part in a ghost hunt.

Just Like Heaven (2005). Reese Witherspoon plays an adorable ghost that you would like to marry.

Ghost Town (2008). A dentist who is not a people person must cope with ghosts who want his assistance.

INDEX

GHOSTS OF NEW YORK, THE TOUR

Get the New York storytelling ghost experience with our licensed guides.

Visit America's most haunted city, the Big Apple, and find the New York of myth, movies and books through Ghosts of New York. Let us see if we can scare you with stories of ghosts, antique sites, ghostly sightings, scandalous tales, haunted places, mysterious sightings of apparitions, strange and unusual tales of centuries past, legendary stories, folklore and ghostly experiences stranger than reality and supernatural intrigues of Manhattan. Listen to the accounts our guides and participants on tours have had on our saunters. Our tales and legends are blended with bits of human interest and historical fact, making them educational for all ages.

Ghosts of New York dedicates itself to verifying paranormal phenomena, occult manifestations and ghostly happenings, as well as the best means of exploring all of this. We want to give you an experience that has no equal. We want to challenge your mental facilities and powers of observation. If you dare, participate in our trek into the unknown, share your ghostly experiences with others and ask yourself: do you believe what you see, hear, smell and touch?

Each tour is ninety minutes long, and the total walking distance is less than one mile, covered at a very leisurely pace so that you can enjoy the mysterious atmosphere and haunted locations. We have many different tours to choose from. We are positive that our tours will enchant, entertain, inform and scare you.

Check out our tours!

Of course, my guides and I at www.ghostsofny.com are among the great tellers of ghost tales. To contact us, go to our website or write us at Ghosts of New York PO Box 656780, Flushing, NY, 11365, or call us at (718) 591-4741.